Introduction

HOW IS THIS BOOK DIFFERENT?

It's simple. It's easy to understand, and it teaches the method I developed in my own self-teaching process. It will thoroughly teach you one style of calligraphy. You can learn, on your own, at your own pace, with dozens of ideas and examples to stimulate your progress.
Most of the book is written in first person; I want you to feel as though I'm talking directly to you in simple language that will help you understand what's going on.

In this third edition of THE KEN BROWN CALLIGRAPHY HANDBOOK, there are more detailed instructions and photographs than were included in the first edition introduced in early 1977, and the second edition first published in the fall of 1982. The first two editions have been advertised and distributed internationally. It has earned a sterling reputation with over 400,000 copies in print.

This book is devoted strictly to techniques and tools for doing lettering with a broad-edged instrument. Even if you're an experienced calligrapher, you'll probably find many tips and ideas that are worth far more than the price of the book.

Ballpoints, technical fountain pens, and other assorted writing instruments won't produce calligraphy. It takes a chisel-edged device, available in myriad designs, to form calligraphic characters. All necessary tools are available at most art stores and, for a nominal investment, you can get the materials to learn at home.

There are worlds of books written to teach calligraphy. Many are excellent. Some are horrible. Build your library with as many of the excellent ones as you can. Study the styles and techniques of other calligraphers. Take what you can from each, but look before you buy. So many publications have few if any photographs. Instead, they have poorly drawn illustrations that often take lots of energy and imagination to understand.

WHO CAN LEARN?

Virtually anyone can learn. Calligraphy is an acquired skill. I've had students in workshops whose ages ranged from 8 to 87. Desire and interest are prime ingredients; those, combined with good hand-eye coordination and proper instruments, will enable almost anyone to achieve great results and satisfaction from calligraphy.

No artistic talent is required to learn. Even if your handwriting is poor, calligraphy is within your reach. Since each calligraphic character is comprised of various common strokes, assembled in the proper sequence,

handwriting is unrelated. You will, however, notice a marked improvement in your handwriting as you spend time learning calligraphy. You'll be tempted to calligraph your checks and that will blow your grocer's mind, not to mention your banker's.

COURSES AND YOUR PROGRESS

Although there are calligraphy courses being taught all over the country, **you do not *need* to attend formal classes to learn.** I'll be the first to encourage you to investigate the class and instructor if courses are offered in your area, but so often people totally unprepared to teach, somehow become the calligraphy teachers. Students become mis-informed, discouraged, and frustrated. Many drop out.

Check out the instructor. Ask about his or her qualifications and find out who has taken the class. Certainly, a qualified, *experienced* teacher can give you one-on-one instructions that will eliminate your problem areas much faster than you can yourself.

Again, this book is all you need if you have the least amount of desire and determination to learn calligraphy.

Have patience and give yourself time. You won't master it in two days, or two weeks, or even two months. You'll see remarkable progress within a few weeks if you allot some time for frequent practice; 30 minutes a day will provide a good foundation for your growth and improvement. Continue to practice and experiment with different styles. Date and keep your practice sheets for weekly comparison to see your skills increase. Proficiency levels vary widely among individuals, so there is no timetable for your own personal development.

Whatever your motivation may be for learning calligraphy, you'll be greatly enriched by your newly acquired skill. You may want to earn extra income or just be able to communicate the written word more gracefully. In any event, ENJOY!

Ken Brown

TIP: Calligraphy is a difficult word for some people to pronounce in 4 variations. Think of it like **photography**. The word is spoken with the emphasis on the same syllables: Pictures are **photography**; lettering is **calligraphy.** You **photograph** a scene; you **calligraph** a poem. One who takes a photo is a **photographer**; one who letters is a **calligrapher**. One **photographed** a scene; one **calligraphed** a poem.

About the Artists

Maybe it was just supposed to be. In the third grade I absolutely hated that rectangular pad for cursive writing. I hated the assignments and homework and I wasn't at all fond of Virginia Baines who taught that class and impressed me as having some sort of foreboding fixation on the abc's. Miraculously, I passed on to the fourth grade the first try. I had learned to write but it was a dull chore.

The next thing I vividly remember about letters was in the sixth grade, but it had no relation to school. My parents hired someone to draw some plans for a new house and I was awed by the man's hand-printing on those plans. His block letters on the dimensions and descriptions amazed me. It was perfectly artistic. For some reason I was captivated by his attractive hand-lettering, but I was still a spectator at that point.

I recall marveling at the way Hugo's sign painter, Henry Lyles, Jr., would letter bold, beautiful script and block letters on signs and billboards around Hugo. I fantasized about being able to create my own billboard someday.

I entered the ninth grade with a great appreciation for hand-lettering, but I had never made a poster and my homework never got extra points for neatness. My handwriting would have passed for a doctor's.

THE OLD MAN ON THE BALCONY

During high school I worked at the local department store selling shoes and shirts after school and on Saturdays. Gene Prater was a kind old gentleman who had worked at the store for decades; he was primarily a shoe salesman, but he was also the official sign-painter for the store.

Almost every afternoon, Gene would go up on his little balcony at the back of the store. I thought it was such a magic place because you could see the entire layout of the store, all its workers, and customers from Gene's perch high above the shoe department. He had a makeshift drawing table, with standing room only, cluttered with a coffee can full of rusty old Speedball® dip pens and flat lettering brushes. There were dozens of partially filled, crusty bottles of red tempera paint he used to letter little price posters and signs all over the store.

Not only was I enchanted by the privacy of his tiny creative corner, I was amazed how such beautiful letters and words could come from his sorely inadequate collection of tools. I'd stand beside him for long periods watching the effortless motions as he hand-scripted signs for every department. He was doing calligraphy but neither of us knew it at the time. He never offered to let me try and I never asked.

THE ARCHITECTURAL CLASS DID IT

When I was there, Hugo High School offered no exposure to calligraphy or art of any kind. I was the typical one-horse town student just marking time to get out of school. I didn't work on the yearbook and never took part in any poster-making for school activities.

I enrolled as a freshman engineering major.....Lord only knows why engineering...at Oklahoma State University in Stillwater. I muddled through the first year struggling with such mind-numbing endeavors as calculus, chemistry, and physics. The first semester of the second year gave me more of the same. I was drowning in the red ink of bad grades.

I lived in an apartment with a bunch of Architectural students, three of whom were my roommates. They were constantly buzzing with enthusiasm about their architectural projects. One day I visited one of their classes and, again, was overcome with the beauty of the hand-lettering on their architectural drawings.

The next semester I changed majors. Architecture looked good to me. During the very first class period the instructor turned a piece of chalk on its side and created some graceful letters on the blackboard. We were told to buy a Speedball® pen, some ink, and poster board and bring something **'hand-lettered'** to class the next day.

THE ASSIGNMENT THAT CHANGED MY LIFE

I fumbled through most of the night in my dormitory room, on my hands and knees, trying to get some decent letters on the board with a Speedball® C-O pen. It was tough. Whatever infatuation I had with letters up to that point had evaporated during the frustration of that all-night assignment.

The next morning I dutifully marched into class with a crudely-lettered 10-line poem under my arm. When I walked inside the classroom I was stopped dead in my tracks. The work of 40 or 50 other students, taped on the wall, left me speechless. Every poster, in my eyes, was a masterpiece.

When the grades were marked on each assignment, mine got a 'mention commendable' which was about the equivalent of a B minus. It didn't matter what grade I received. Seeing the work of the other students changed my life. Although the word 'calligraphy' was never mentioned in that class, I was determined to learn beautiful hand-lettering.

My grade in that class was the best I had received in any class that semester, but I left college at the urging of the dean of men, since my grade point average for two years was barely a whole number. That was the spring of 1961.

I began my working career that summer as a radio announcer, changed later to a mechanical draftsman,

6

THE
KEN BROWN

Calligraphy

HANDBOOK

THIRD EDITION

Created and Produced
by
KEN BROWN

Published by
THE KEN BROWN STUDIO OF CALLIGRAPHIC ART

First edition and design, copyright 1977
and published by
The Ken Brown Studio of Calligraphic Art
Irving, Texas 75061

Second edition and design, copyright 1982
and published by
The Ken Brown Studio of Calligraphic Art
Hugo, OK 74743

Third edition and design, copyright 1991
and published by
The Ken Brown Studio of Calligraphic Art
Hugo, OK 74743

Book concept and teaching techniques created and
produced solely by Ken Brown.

Most of Ken Brown's calligraphy was done with various
pens, papers, and inks produced by
HUNT MANUFACTURING CO.

Sample artworks through the book feature watercolor
paintings by Gail Brown and calligraphy by Ken Brown and
are copyrighted by The Ken Brown Studio, Inc.
Reproductions are available upon request.

Most of the photography was done by Kevin Brown. Photo
credits also include Gail Brown, Ken Brown, and Lyndol
Fry. Michael Penn Smith shot the front cover and inside
back cover publicity photo.
Ann Cooper shot the back cover.

Most instructional photos were shot with a Mamiya RB 67
using Kodak® TMAX® film. Black and white developing,
printing, and all darkroom work done in-house by Ken
Brown, using Kodak® chemistry.

Book page layout and typesetting were created by
Ken Brown on an Apple® Macintosh II
desktop publishing system.

Type set in Optima with high resolution page output by
Express Typesetting in Dallas, Texas.

Book printing and production by
Allcraft Printing in Dallas, Texas.

ISBN 0-9630231-0-1

Library of Congress Cataloging-in-Publication Number
91-073547

10 9 8 7 6 5 4
Digit on the right indicates the number of this printing.

09938M

Distributed to the trade by
HUNT MANUFACTURING CO.
230 S. Broad Street
Philadelphia, PA 19102
215-732-7700

Calligraphy

Learn A More Beautiful Way With Words

✝

In this book you'll discover the joy of self-expression through one of history's oldest artforms. Calligraphy is elegant, useful and extremely rewarding to those who learn the art. You need not be an artist to become an accomplished calligrapher, but one dedicated to the practice required to develop the skill.

This book belongs to

Personalized this date, _____ *,by* _____

Dedication

Several people along the way during these past 30 years have had a profound influence on me and the development of my calligraphy. Each, in his or her own way, left an indelible mark on my life. This book is dedicated to them.

Virginia Baines
My third grade teacher whose quest it was to create in each student the ability to write longhand as well as whoever created those miserable rectangular penmanship pads that I hated with a yet unknown passion. It was dreary punishment to fill those endless sheets with cursive letters. Her most horrible assignment was 30 pages in the book to be completed over Christmas vacation in 1948. There was never a moment's joy in that part of my third grade, but it must have been a building block.

Unknown
Some gentleman who drew house plans for my parents in 1951. His flawless printing on those drawings fascinated me.

Simon Parker
My Hugo High School Principal who became my very special friend. He liked my calligraphy and, through the years, he gave me hundreds of scraps of paper, clippings, and books with quotes, proverbs, and homilies he loved so much. I'll always remember his great sense of humor and his favorite saying, shared with us often during our school assembly programs:
"A big shot is just a little shot that kept on shootin'."

Gene Prater
A kind gentleman I worked with at the local dry goods store during my high school days, 1955 to 1959. It was magic to watch him hand-lettering the prices for merchandise throughout the store. His talent impressed me with every flourish of the old flat brushes he used on those thin, white posters.

W. George Chamberlain • Rex Cunningham • Jim Bruza • Jim Knight
The four instructors in my one-semester stint in the school of architecture at Oklahoma State University in the spring of 1961. **Mr. Chamberlain** was the one who went to the blackboard the first morning and, with a piece of chalk turned on its side, made beautiful letters. **Mr. Cunningham** was a fabulous watercolor artist who lent his hand during the painful rendering of our design projects. **Jim Bruza** was a student teacher whose positive comments about my first lettering gave me great hope. **Jim Knight**, also a student instructor, was patient and understanding with my continuing difficulty in the architectural design part of the class. He saw strength in my lettering and encouraged me with his approval.

Jerry Bartos
A young entrepreneur I worked for in Dallas from 1966 to 1969. Jerry taught me the value of time, the success of perseverance, and the pleasure of working. His unbridled enthusiasm and dedication to his goals are still important guideposts for me.

Roy Holcombe
The owner of the small craft shop in Irving, Texas, where I took a sample of my work in early April of 1970. He saw merchandising potential in my calligraphy and, in the spring of that year, he bought 1000 copies each of 8 different pieces. He became our first distributor from a casual visit to the store one Saturday afternoon.

Hal & Jean Wortham
A married couple Gail and I met at a craft show in Dallas, Texas, in the summer of 1970. They saw a chance to help a couple of struggling artists become established nationally, as they were. We only had one brief visit in their show booth; a week later they sent us a check for $150.00 and stipulated that we must buy a small ad in some national arts and crafts magazine. They said the money was a gift, not to be paid back; they asked that we pass along a similar favor for someone else when we could. That ad gave us national exposure and a giant leap into business. It also taught us the joy and virtue of sharing.

Ray DaBoll
The man I'll always remember as having the greatest impact on my desire to make something out of calligraphy. Ray lived on a farm in Batesville, Arkansas, when I met him in March of 1971. He was a retired commercial artist, specializing in calligraphy, in Chicago, during the 40's and 50's. His praise and encouragement inspired me. His letters and pieces of original work he gave me are some of my favorite treasures.

Art Astorino
A man, then with Hunt Manufacturing Co., who came to Hugo in 1976, asking me to create an instruction book. He saw greater horizons for my calligraphy and encouraged me to write a book to teach others, long before I had seriously considered teaching or developing a system. Through his help, The Ken Brown Calligraphy Handbook, in its first edition in 1977, became a reality.

and went from that to selling air conditioners. What a humbling experience that was. From there I became a promotional writer for WFAA-TV, the ABC affiliate in Dallas, Texas.

I covered lots of ground from 1961 until 1972, with an undying love for calligraphy. Regardless of what else was going on in my life, I did calligraphy almost every day. My lettering steadily improved, but, until 1971, I didn't know another soul, personally, who shared my interest and skill.

After 4 wonderful years in television, I had to make a tough decision. Television was interfering with my calligraphy. Every spare moment away from my job was spent doing and hustling more calligraphy work. I found myself months behind and better paid as a moonlighter, so I quit my 'day job' and formed The Ken Brown Studio of Calligraphic Art in September, 1972.

To date, over 40 million impressions of my calligraphy have appeared on art prints, magazine ads, videos, kits, books, calligraphy markers, and various other tools.

Photo by Kevin Brown

Nobody on either side of my family has one whit of artistic talent. Whatever the level of my proficiency....which is far below many other calligraphers....I've learned and gotten there on my own. I've shared everything I know in this book. Oh, if only I'd had something as basic and complete as this to help my early trials in learning.

Use this book and be patient with yourself. Whatever you do, and however well you do it, relax and have fun with your calligraphy. It can be richly rewarding regardless of the direction you take it.

-Ken Brown

Photo by Kevin Brown

Gail and I had been married eight years before I was aware of her artistic abilities. She had done a few oil paintings and sketches during high school, but she did no artwork after we were married. In 1970, Gail did a charcoal drawing that was faintly printed in the background of a poem I did, **My Kitchen Prayer**. We sold 1000 copies of that piece, featuring both our work, to a craft outlet in Irving, Texas. Within a year we had done another two dozen pieces combining our two kinds of art.

Gail's artistic abilities are also self-taught through lots of practice and research. In 1982 she began producing watercolor paintings for the first time. Many were designed specifically for my calligraphy and some were not. By the end of 1990 over ten million reproductions of Gail's paintings had been sold around the world. Several of our combined works are printed in black and white throughout this book.

Gail and I will gladly send you a couple of complimentary samples of our combined works. Write to us and be sure to put FREE PRINT REQUEST on the outside of the envelope.

KB

Contents

Introduction.. 9
The Tools... 10
Calligraphy Markers.. 11
Dip Pens.. 12
Reservoir Pens... 14
Decorative Dip Pens....................................... 16
Scroll Pens.. 17
Alternate Tools.. 18
Drawing Boards.. 24

THE WORKSHOP SECTION............25

This section is for designed for teachers conducting workshops and for those who want to get started learning and practicing immediately.

The Rules.. 26
Left-Handers.. 30
Developing The Method.................................... 31
Starting To Learn... 32
Your First Sentence.. 35
Spacing.. 36
Ken Brown Old English................................38 & 39

Chancery Cursive Lower Case Strokes......................... 40
Chancery Cursive Lower Case Worksheets................... 41
Numbers... 47
The Ken Brown Calligraphy Practice Pad Sample......... 48
Gail & Ken Brown Samples.................................... 50
Chancery Cursive Upper Case Strokes....................... 55
Chancery Cursive Upper Case Worksheets.................. 57
Layout.. 61
Flourishes... 68
Ascenders & Descenders..................................... 69
Lettering On Wood.. 70
Declaration Of Independence on Wood..................... 71
Lettered Letters... 72
Uses for Calligraphy.. 74
BrownLines Newsletter Sample Pages....................... 76
Questions Often Asked....................................... 78
Calligraphy Supplies Order Form............................ 79
Ultra High Speed Engraving of Calligraphy................. 81
Ken Brown Wall Charts....................................... 83
Thanks .. 84

The Origin of Calligraphy

Let's take a brief look at the history and development of this artform. First, the definition of calligraphy: kal-lig'ra-fe (Greek - kalos, beautiful, and grapho, to write). Calligraphy is the art of beautiful writing. Fair or elegant writing, or penmanship. Calligraphy is not a word found in everyone's vocabulary. Even though calligraphy is the very basis of handwritten communication, few people know of its origin and use in centuries past.

In this age of electronic communications, including electric typewriters, word-processing computers, and high-speed printing presses, not much time or thought is given to elegant writing. A quick note dashed off with a ballpoint pen, or a hastily typed letter serve to transmit our written thoughts and messages. There is nothing hasty about calligraphy. Its history long predates all our familiar instruments and its beauty sets it apart from the faster, less personal, mechanical means of communicating.

Written communication dates back 20,000 years before Christ. Discoveries show that primitive cavemen, in these beginnings of writing, mainly used simple pictures. The developmental stages of writing took thousands of years and there were mixed features in the long period of transition.

From the early decades of the Roman Empire, until the 15th century, calligraphy was stimulated, cultivated, and shaped because it was required in the production of books. The products of the skillful scribes had been necessary to publish the works of Cicero, Seneca, Platus, and the other great statesmen and orators of the time. Most important was the need to multiply copies of the Scriptures and the other service books required of religious observances. In the 15th century the unquenchable thirst for books could not be satisfied, even by the ceaseless efforts of the scribes. Man was forced to invent a way to mass-produce these texts without the dependence upon man or pen. This vast need existed until the first day of printing with moveable type, invented by Johann Gutenberg in about 1440.

The forerunner of paper was papyrus, handmade in Egypt from a reed-like plant. Through an elaborate process, the Egyptians produced papyrus, from vertical and horizontal strips of the pith of the plant arranged in two layers with the strips touching, laid side by side.

In Egypt, classical Greece, and Rome, the tool for writing on papyrus was the hollow reed of certain plants. They used carbon inks for writing on papyrus. Carbon ink is essentially a mixture of soot and gum, or glue, mixed with water. The soot of fine lampblack was prepared by burning wood or oil. Other ingredients were often used to produce different colors and degrees of hardness and durability.

For scratching the surface of a wax tablet, a stylus of ivory, bone, or metal was used. Quills from the goose, swan, turkey, raven, and crow also served as pens. Bronze pen-tips were made by the Romans for writing a rustic script. Around 1831, the quill and other improvised points gave way to a patented steel pen of much higher quality.

In Europe, paper began to be used for less important documents in the 14th century. Prior to that period it was a rare commodity used only for special purposes. A paper mill was later established in England in the 15th century.

Another writing surface for medieval calligraphy was prepared animal skins. These skins are still in wide use today for very special documents such as resolutions and proclamations. The skin known as vellum comes from calves; parchment, the more widely known medium, comes from the skin of lambs. The finest vellums are the skins of unborn or stillborn calves. These two surfaces are very costly and the best sources are in England, although a few firms in the U.S offer them.

The tools now used for calligraphy, though basic in design to those used centuries ago, are vastly improved. The scribal monks would have danced in the monastery for the precision pens, scientifically formulated inks, and highly refined papers available today.

The Tools

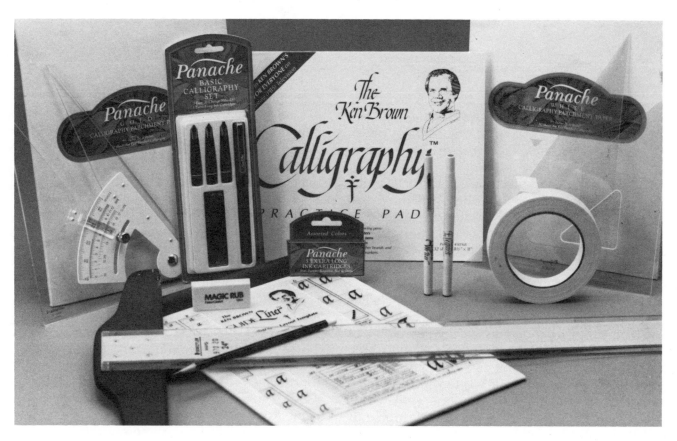

These are the items to get you best prepared to learn calligraphy. Ask your local arts and crafts store for calligraphy supplies from *HUNT MANUFACTURING CO.* and *KEN BROWN*.

ABOVE:
- Panache™ Basic Calligraphy Pen Set containing 1 barrel and cap, 3 nibs in Fine, Medium, and Broad. Also included are 3 extra long ink cartridges in black, blue, and purple.
- Panache™ assorted ink cartridges in blue, purple, turquoise, red, and green.
- Panache™ parchment papers in white and gold.
- Elegant Writers® in Fine and Broad for practice in this book.
- Ken Brown Calligraphy Practice Pad with pages specifically designed for over 20 different pen sizes and types.
- Soft-leaded pencil (2B or softer) for guidelines.
- Soft white eraser for removing guidelines.
- Draftsman's or masking tape.
- T-square for parallel lines on your work surface.
- Ken Brown Calligraphy GUIDELiner® for easy layout of guidelines for any size or brand of pen you use.
- Plastic triangles for drawing vertical lines or angled lines on your layout. Adjustable triangle can be set to any desired angle for letter slant.
- Tracing paper for the exercises in this book and to help with layout.

LEFT: Four Ken Brown videos are the nearest thing to a private lesson. Titles include Chancery Cursive, Old English, Uncial, and Tips, Techniques, and Profits. You'll be able to work along and see every stroke of every letter done with a variety of pens and markers. Full of ideas and examples to help you learn and earn.

Calligraphy Markers

I cannot imagine a world without calligraphy markers. Even though they have a limited life compared to durable metal dip and reservoir nibs, they're marvelous for lots of projects. They're colorful, there's a wide ranges of sizes, and there's never an ink flow problem. Elegant Writer® Calligraphy Markers from Hunt Manufacturing Co. are my favorite. I use them every day for informal notes, to personalize my books, and for rough drafts that will later be used as guides for production with my Panache™ reservoir pens or Speedball® dip pens.

I recommend Elegant Writers® for virtually all your practice sessions in this book. You'll spend all your time concentrating on calligraphy and none worrying about filling, refilling, and running out of ink. Look at the wedding invitation I did with Elegant Writers® on page 67. Although you should never use markers for work to be reproduced, this example proves that markers can perform far beyond practice and informal notes.

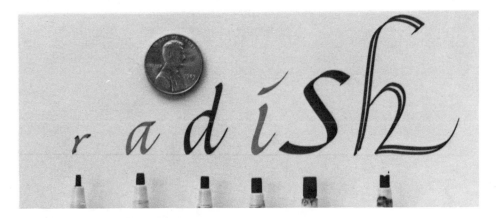

TOP: Close-up of Elegant Writer® Broad point, front view.
ABOVE: Close-up of same point, side view.

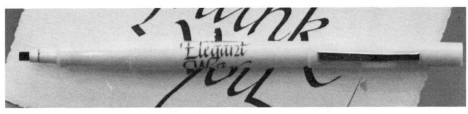

TOP: Elegant Writer® Calligraphy Markers, left to right, in Extra Fine, Fine, Medium, Broad, Extra Broad, and Scroll. All are non-permanent.
ABOVE: Elegant Writer® Calligraphy Markers come in several shades indicated by color of the lettering on the pen barrel.

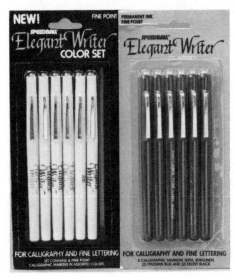

LEFT: Other available Elegant Writer® pen sets, including the series of Classic pens which are filled with permanent, waterproof ink.

NOTES ABOUT CALLIGRAPHY MARKERS

Advantages Excellent for beginners, especially kids. Easy to carry in pocket or purse. Fast and easy to use with no ink worries. Great for daily practice, informal notes, invitations, posters, and fancy envelopes. Inexpensive and widely available.

Don'ts Never do important originals with markers; their points begin to lose the sharpness and your piece will lack consistency in thicks and thins from start to finish.
Never attempt to sharpen a marker's point with a knife or razor blade. It's virtually impossible to trim or reshape a point to its original square form. Uneven, ragged letters will result.

The Ken Brown Calligraphy Handbook • © 1991 Ken Brown Studio

Dip Pens

Although dip pens are the least expensive of all the calligraphy pens available, they are the most difficult to use. At the same time, they play a vital role in the overall activities of producing great calligraphic work. When you want to use india ink or heavy, pigmented colors that won't flow in reservoir pens, use these wonderful Speedball® nibs.

There's a broader range of point sizes and they need less maintenance than reservoir pens. I keep 3 or 4 same-size nibs for colors. For example, I'll have a C-O for black, another for red, and another for green. I'll have several C-1 nibs, each to be used only with its assigned color. It takes a fist-full of nibs and pen staffs to set up this way, but it saves an enormous amount of time and hassle. Otherwise, I'd have to stop and thoroughly wash out one color to prepare for the next if I only had 1 nib of each size.

These pens almost require a sixth sense to know precisely when to stop and refill the tiny reservoir. If you wait too long, you'll run out mid-stroke and it will be difficult, if not impossible, to exactly line up the pen in the unfinished stroke after refilling.

These were the very first pens I used in 1961 when my love affair with calligraphy began; I still use them almost every day. You should have a good supply of the Speedball® C-Series pens.

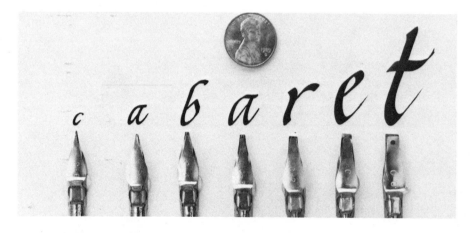

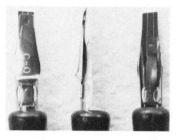

Front, back, and side views of Speedball® nib. Capillary action makes ink flow from tiny reservoir, down slits, to the lettering surface. Be careful not to destroy the spring tension on the brass reservoir cover when cleaning the nib.

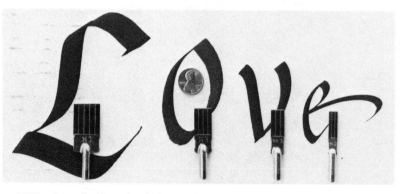

TOP: Speedball® nibs, left to right, Sizes: C-6, C-5, C-4, C-3, C-2, C-1, and C-0

ABOVE: Speedball® Steel Brushes. Left to right, Sizes: 3/4", 1/2" 3/8" & 1/4." These pens are excellent for all inks, temperas, and watercolors when you need larger letters than can be made with other dip and reservoir pens.

RIGHT: This was during the taping of my first Public Television series, CALLIGRAPHY WITH KEN BROWN. I've done a poster with my favorite Steel Brush, the 3/4."

Dip Pens

This might be called the 'care and feeding' of dip pens. They play such an important part in calligraphy and the pens must be properly maintained to work well. I'm probably the worst violator of good housekeeping with dip pens. Always fighting a deadline, I usually finish with a pen, chunk it on the shelf and forget it until I need it again. Then, I have to go through the routine of washing and cleaning to get it ready for another job.

Don't be afraid of the Speedball® pens. Try them, but be sure to follow the 3 steps in item 2 below. Once you get the feel of the pens, through using them, you'll develop the 'sixth sense' I mentioned and they'll be a joy to use. At the same time, develop better habits than mine and clean your pens after each use.

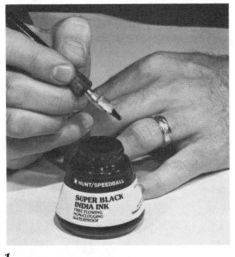

1

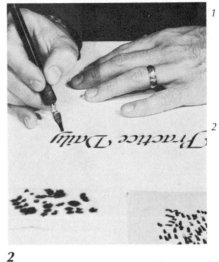

2

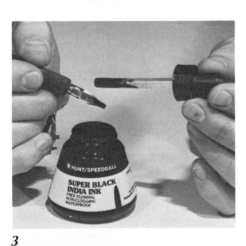

3

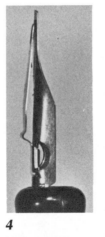

4

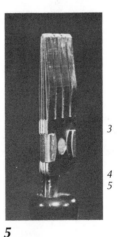

5

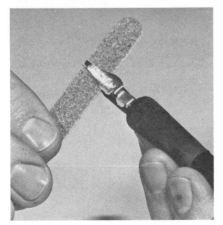

6

7

1 When filling the dip pen directly from the bottle, immerse <u>ONLY</u> about 1/3 of the point in the ink. The small metal flap, shown in picture 4, forms a tiny reservoir that gravity-feeds ink to the tip. If the entire point is immersed, the weight of the ink will make too much flow onto the paper the instant it touches. Always have a damp paper towel and a piece of scratch paper near your work with a dip pen. After each ink refill, do these three steps:
(1) Drag the point across the bottle lip.
(2) Touch the point to the damp towel for an instant; don't hesitate or all the ink will be pulled out.
(3) Make several short marks on the scratch paper to establish an even flow.
After the 3-steps, your pen will be ready to form another few strokes or letters before needing more ink. Soon, you'll sense when the pen is running dry. Don't continue until the flow stops completely; it'll be difficult to match the pen position if you run out in the middle of a stroke.

3 An eye-dropper is a more precise way of filling the reservoir. Follow the same 3 steps before proceeding to your work sheet.

4 Side view of a typical dip pen.

5 The STEEL BRUSH is designed for posters where letters are required that are larger than the regular dip pens will make. The STEEL BRUSH will make beautiful calligraphic letters when the four rules are followed.

6 When finished, after EACH use of a dip pen, use an old toothbrush and warm running water to clean the ink off the point. If the ink is allowed to dry, the pen won't flex and function properly. If this should happen, Clean with an emery board or a fine-grain sandpaper. Gently slide the sanding surface between the flap and the pen; be careful not to destroy the spring tension on the reservoir flap. Sand underneath the point also. After sanding, clean again under the water. Dry thoroughly.

7 My home-made dip pen and ink caddy.

The Ken Brown Calligraphy Handbook • © 1991 Ken Brown Studio

Reservoir Pens

Most of my calligraphy is done with reservoir pens. They provide steady, consistent ink flow and their precision points give sharp, crisp strokes hour after hour. There's never a worry about running out of ink in the middle of a letter and I may only have to change ink cartridges every couple of weeks, depending upon how much lettering I'm doing.

My favorite reservoir pens are Panache™ brand, imported from Great Britain. These pens are manufactured to exacting tolerances with a great range of nib sizes and ink colors. As you see below, I can do tiny letters, from about 1/16" tall to letters over 1" tall with Panache™.

All reservoir pens work basically in the same way and require the same care and maintenance. The differences are in construction of the nibs and ease of cleaning. Panache™ pens are the best available.

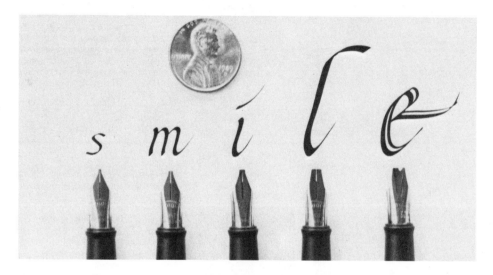

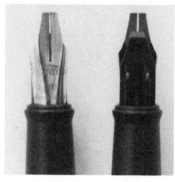

Front and back views of the Panache™ Broad nib. Its best feature in the single slit. With only two sections, the nib is stronger and stays sharp and straight. Other manufacturers produce nibs in this width with 2 slits, making three sections that easily get out of alignment and create scratchy, uneven strokes.

TOP: *Panache™ series of reservoir pens, left to right, in sizes: Extra Fine, Fine, Medium, Broad, and Scroll. These pens are designed for use only with specially formulated Panache™ inks.*

ABOVE: *Panache™ pen with the Broad nib.*

TIP: If you procrastinate in the pen cleaning department, this will save the day. This ultrasonic pen cleaner costs about the same as dinner for two in New York so, unless you ruin lots of pens, you may not be able to justify this wonderful tool.

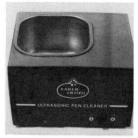

NOTES ABOUT RESERVOIR PENS

<u>Advantages</u> Nibs produce consistent, well-defined strokes. With proper care, they're worry-free and will allow total concentration on your lettering project. With multiple pens, for different nib sizes and ink colors, you'll save time on projects using a variety of letter heights and colors.

They can be carried in pocket or purse for immediate access when you want to impress someone at lunch or by writing a fancy check to the shoe store. They will last for years and years if cared for correctly.

<u>Don'ts</u> Never load them with permanent ink unless the pen manufacturer makes the ink and says you can. It takes specially formulated permanent inks to work in reservoir pens; the quickest way to ruin your pens it to use the wrong ink.

Never produce an important original with non-waterproof ink without sealing it with a protective aerosol spray. Wait until the ink is dry to lock it away from moisture. Even the slightest touch of dampness will make the ink bleed and run.

Reservoir Pens

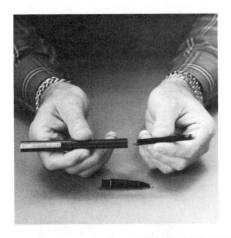

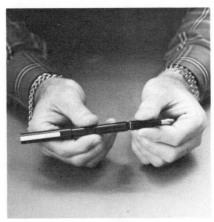

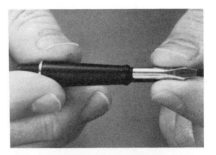

LOADING THE CARTRIDGE

Insert the <u>colored</u> end of the extra long Panache™ ink cartridge into the pen barrel. Push it down until it stops. Hold the nib in your left hand. Insert the ink cartridge, that is sticking out of the barrel, into the open end of the nib. Turn the barrel <u>clockwise</u> until it is screwed snugly onto the rear of the nib. The cartridge will snap into place in the rear of the nib; it will be punctured so ink will gravity flow down to the point.

Loading the cartridge

Follow the steps described with the first two photos above. Hold the pen in an upright position; ink should begin to flow in 30 to 60 seconds. To speed up the process, touch the nib to a wet paper towel to bring ink down to the nib's end. Another way to quickly bring ink to the point is to remove the barrel and gently squeeze the cartridge until a drop of ink rolls down to the end of the nib. Be careful to hold the point over a paper towel or the wastebasket during the brief squeeze.

Checking the cartridge

After you've worked a while and your pen's ink flow begins to slow or stop, first check the cartridge to be sure it's not empty. Unscrew the barrel and hold the cartridge, while still plugged into the back of the nib, up to the light. Tip it back and forth to see if ink runs from one end to the other. If you see no ink, remove the empty cartridge and plug in a new one of the same color.

If you see ink still in the cartridge and the ink won't flow, the nib is dirty and must be cleaned for proper ink passage.

Cleaning the nib

To clean, merely grasp the nib and pull it straight out of its round plastic housing. You'll remove the metal nib and the grooved plastic piece behind the nib. Hold both under warm, running water and gently clean them with liquid soap and an old toothbrush. When clean, carefully towel dry the nib and grooved piece.

Hold the round housing under fast running, warm water to flush out any residue that may have built up inside. When finished, shake the water out, then towel dry. Use a cotton swab to get it completely dry.

Re-insert the metal nib and grooved piece into the round housing. Re-insert the same cartridge and give it a gentle squeeze before screwing the barrel back on.

Changing colors

Any time you change colors in the same nib, follow the procedure for cleaning the nibs as outlined above. Be especially careful to remove all the previous ink to avoid contamination of colors. You'll quickly ruin your work if you introduce another color into the nib unit having traces of the previous color. After you've washed, dried, and changed colors, <u>always</u> test the new color on a separate piece of paper before you go back to the project. If there's

CLEANING THE NIB

Grip the nib tightly and pull out of the housing. If dried ink has it 'locked' in place, soak it in warm, soapy water overnight. After soaking, use a washcloth to help you get a better grip and try again. <u>Never</u> use pliers to remove clogged nibs.

If your nibs get hopelessly 'frozen' with ink residue, from neglect, they can usually be saved from the garbage by investing in an ultrasonic pen cleaner. With high-frequency vibrations and cleaning solutions, these salvage your prized points.

any hint of color mixing, repeat the cleaning procedure and test again.

Avoiding the hassle

<u>You can save lots of time and the loss of momentum by having at least 2 or 3 extra Panache™ pen barrels.</u> Keep different nib sizes and colors in the extra barrels and when there's a need for a change, merely cap one pen and pick up another, loaded with the color and nib you need.

Until you've worked on a piece requiring several changes, and you only have one pen barrel, you can't imagine the anguish of having to break the rhythm of your work to stop and change something.

The Ken Brown Calligraphy Handbook • © 1991 Ken Brown Studio

15

Decorative Dip Pens

Some of the most attention-getting projects in my Public Television series were done with Coit Pens. This special breed of dip pen will enable you to make creative expression and experimentation easier and more fun than ever.

If you need to make big posters, charts, and banners with a genuine flair, these pens are absolute magic.

Below are the pens and the relative size letters they'll make. I love to use them for big, dramatic first letters, headlines, and names on huge birthday cards.

Ask your art store for COIT pens and add them to your supply of Panache™, Elegant Writers®, and Speedball®. If unavailable locally, ask The Ken Brown Studio for more information.

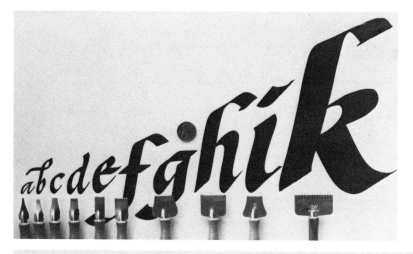

Artwork of the hand, multiple renderings of the capital 'B', and the group of the letter 'm' were all done by Arthur Baker and are reproduced here with special permission from COIT CALLIGRAPHICS, Georgetown, CT.

Sample letters, above each pen, were calligraphed by Ken Brown.

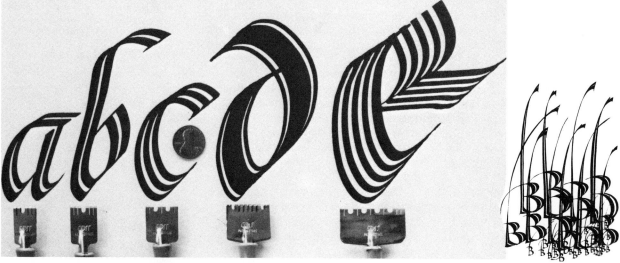

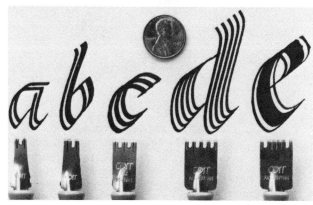

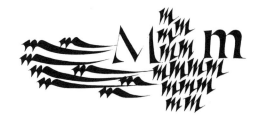

Scroll Pens

You can add depth and dimension to your calligraphy with two kinds of lettering pens that create a double line in each stroke.

The Panache™ nib produces the beautiful effect of each stroke casting a shadow, almost giving letters a 3-dimensional look. One line is thick and other is thin.

The Elegant Writer® has a v-notch that produces same-width parallel lines as each stroke is made.

The pens are held and used just as any other pen, although it is more critical to maintain a precise 45 degree angle at all times, so the two lines will converge to a sharp point on most ending strokes.

Below are examples of how these pens can add so much flair to calligraphy. Experiment with them and find ways of adding pizzazz to your own work.

Panache™ and Elegant Writer® are products available through HUNT MANUFACTURING CO.

Panache™ Scroll nib

Elegant Writer® Scroll Pen

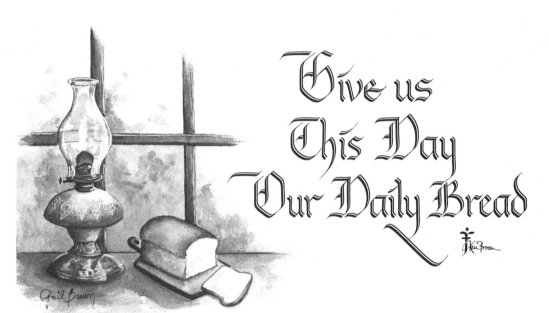

Give us This Day Our Daily Bread

Lettering like this can be done with the Panache™ SCROLL nib.
Calligraphy by Ken Brown and illustration by Gail Brown.

"God never loved me in so sweet a way before,
'Tis He alone who can such blessings send,
And when His love would new expressions find,
He brought thee to me, and He said,
'Behold a friend.'"

Hal Thornburgh, from West Plains, MO., was in his 80's when he did this work with an Elegant Writer® Scroll pen.

practice daily K S L

This was done with an Elegant Writer® Scroll pen.

The Ken Brown Calligraphy Handbook • © 1991 Ken Brown Studio

Alternate Tools

OTHER LETTERING TOOLS

One of the most delightful aspects of calligraphy is the opportunity to use it in unusual and unexpected ways. I've used screwdrivers, chisels, popcicle sticks, and foam brushes for various not-so-formal projects. I've lettered on rural mailboxes and the soles of tennis shoes. I've put names on ice chests, footballs, boat oars, and little red wagons. One of the most lasting jobs was done in the sidewalk in front of the local cafe.

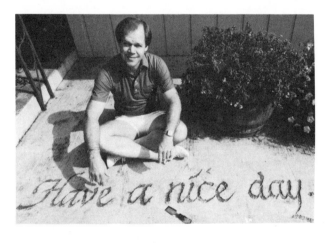

*Seldom do you get to sit in the middle of your finished calligraphy, but I did on this job, done in wet cement with a **2" wood chisel**. The disadvantage in lettering on this surface is working without guidelines.*

One day, as I arrived at the parking lot of our favorite local restaurant, the owner was overseeing some concrete work being done in front of the cafe. Jokingly, he said, "Hey Ken, why don't you do some calligraphy in the wet cement?"

In a flash I put my lunch plans on hold, raced back home, got a **2" wood chisel**, and returned to the fresh concrete. I quickly surveyed the available space, then knelt by the wooden forms with chisel in hand. There was just enough room for "Have a nice day", my signature, symbol, and date. That was several years ago and I'm certain my spur-of-the-moment calligraphic creation, with a wood chisel in wet cement, will greet diners at that restaurant for many years to come. It's not exactly the Hollywood Walk of Fame, but I did get my name and the print of my hand in some wet cement.

Another of my favorite calligraphy tools is a ***giant felt marker***. Quite often, I'll letter a huge banner of *Welcome, Congratulations,* or *Happy Birthday* on a big roll of butcher paper. These hefty markers come in several colors and produce sharp, crisp strokes and letters that always grab attention.

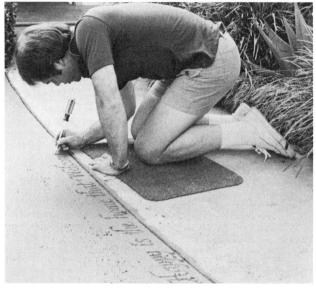

Photo by Lyndol Fry

Here's another project in wet cement. When our patio was poured I used a chisel-edged **screwdriver** to letter "Happy is the home that welcomes a friend." Just for balance, on the other side of the patio, I lettered one of Ben Franklin's homilies, " Fish and Visitors stink after three days."

Since you cannot hold it like a pen, it takes practice to get the proper angle of the marker to the paper, but you can create larger-than-life calligraphy that never fails to draw appreciation.

One other slight problem in working with these colossal markers, is space. When I first discovered them, I'd roll the paper down the short hallway in my office; if my message was very long, I would take it to the street. If it was the least bit windy, managing a 40' piece of paper was impossible. Even with no wind, the street would always wreck my knees and hands. Then there was the traffic. A few of the local folks questioned my sanity in taking over the section of street by the side of my office.

Now, I have a folding table, right in my studio work space, with a paper dispenser mounted on the right end. I stand in the same spot, lettering the message, while I continue to pull more paper out in front. The ink dries immediately, so there's no problem in letting it do an accordion fold at the left end of the table.

One of the most appreciated banners was a 40' message taped across the front of a fellow church member's house. It was a great welcome home for Judge Henry Braswell and his wife, Rachel, after an extended hospital stay.

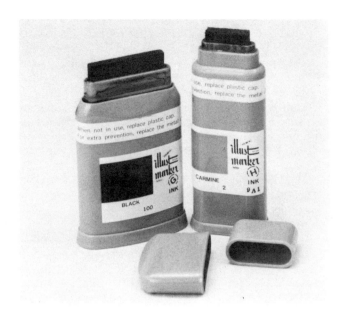

Giant ILLUST felt marker imported from Japan. They come in two widths and several colors. Ask your local art dealer for them or write to THE KEN BROWN STUDIO for more information.

Another great feature of these markers is the variety of available colors. I use a light gray to shadow special words that may have been done in red, blue, or green. Of course black is the one I use most.

Often, I'll use an X-Acto® knife to cut a small notch or two in the markers to give the same effect the Panache™ and Elegant Writer® Scroll points give. If I change the position of the v-notches, it changes the final appearance of the letters. It's fun to experiment with the felt tips on these giant markers since they're removable and replaceable. You can have several tips with different notch patterns for use in the same reservoir

Above are two variations of notches cut into the felt tips with an X-Acto® knife. Notice how the letters are different.

which always has the same color ink. With care, these wonderful tools will last for years.

When I've completed the lettering, I usually roll the banner up, starting with the end where the message finishes. I'll tie a big red ribbon around it and either present it personally, or I'll ship it in a mailing tube. Sometimes, if it's for someone local, I'll ask a florist to deliver it with a bud vase and a rose. Of course that depends on the person and the occasion for which the banner was made.

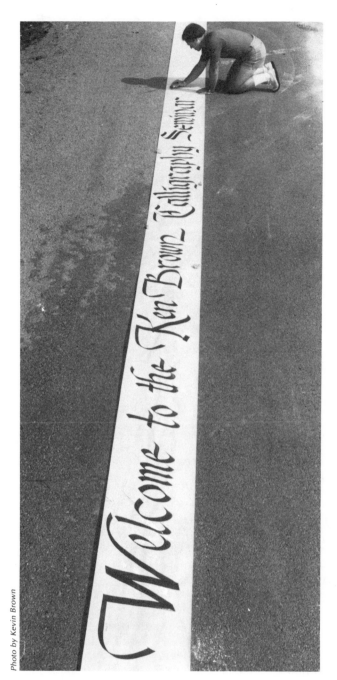

Photo by Kevin Brown

Luckily, it was a slow traffic day and I was able to take over the street long enough to letter this workshop banner. This was before my special table with a paper dispenser.

INKS

It's vitally important that you understand what inks can be used in which pens. Much of the aggravation calligraphers endure is caused by the wrong combination of pens and inks.

Water Soluble Ink Always use non-waterproof ink in reservoir pens. The color of the ink comes from liquid dyes; there are no solids to clog the tiny passages and capillaries through which the ink must flow from the reservoir to the end of the nib, and onto the paper or writing surface. If you're doing a larger headline or word than you can make with the largest reservoir nib you have, use the same water soluble ink the dip pen so the inks will match, otherwise you'll be able to see the ink change on the finished piece.

The Ken Brown Calligraphy Handbook • © 1991 Ken Brown Studio

Permanent Ink Most black permanent inks have carbon black or other solids in suspension that will produce the dark, rich black. These inks will readily wash out of the dip pen when you've finished. Unless specifically advertised for reservoir pens, which few permanent inks are, use them **only** in dip pens or brushes. There are a few waterproof inks that will work in reservoir pens. Again, be sure it says that on the container.

Speedball® makes a wide range of ink colors both in waterproof and non-waterproof. These inks have excellent opacity and flow characteristics and are suitable for all dip pens including the Speedball® Steel Brush and Coit pens.

Opaque Inks These are color inks with various pigments and solids that will not flow in reservoir pens. Use them only in dip pens or brushes and wash the letter instrument thoroughly after use. **Never** put opaque inks in reservoir pens.

Outdoor paints These will be too thick to flow in any letter pens. If you lettering is to be on an outdoor sign, mailbox, boat, etc., ask your paint store owner for the best paint and use a flat brush for the calligraphy. Make several test runs on paper until you have the paint thinned to just the right consistency to flow well. Practice for a while until everything begins to feel right.

PAPERS

The right or wrong paper can make a world of difference in your calligraphy. Pick a paper that's too fibrous, too slick, too rough, or non-absorbent, and you'll want to chunk your pen into the next county. When you're working on a paper that allows your ink to flow and dry quickly, you'll feel on top of the world.

Experiment with several papers for every job you do. Visit local printers or paper wholesalers where commercial printers buy papers. Ask for sample swatches of other paper stocks. When you find a paper that works well with your pens and inks, take a piece of it back and ask for additional sheets. Depending upon your needs and budget, they'll cut any amount to any size you specify.

Papers for Practice

Lined Calligraphy Practice Pads Some are available that are specifically designed for different pens and lettering styles. The best, and only one of its kind, is **THE KEN BROWN CALLIGRAPHY PRACTICE PAD.** It will accommodate, with properly spaced lines, over 20 different kinds and sizes of pens including dip pens, markers, and reservoir pens. This pad will speed your learning and development faster than any other way as you practice on sheets with lines and spaces to exactly

fit whatever pen you're using.

Legal pads Like the gridded pads, the line spacing might only be correct for one or two nibs. When you use other pen sizes, you'll either have to draw extra lines at the proper place, or guess at it as you set the bottoms of your letters on the pad's printed lines.

Tracing paper A good grade of tracing paper is necessary for practice when tracing the basic strokes and letter as provided in **The Ken Brown Calligraphy Handbook** and The **Ken Brown Guide to Old English.** You can trace the sample strokes and letters, with guidelines provided in these books, and do your lettering on the tracing paper without marking in the books themselves. Save your tracing paper practice sheets; date them and save for future reference.

Typing Bond Since there are no lines on typing bond, you'll have to draw your own, or work on a light table or light box with a clear plastic lettering guide taped to the glass. Generally, you'll find bond is a good lettering surface but you may find some stocks that will cause your ink to bleed or 'feather' with the ink you're using.

Gridded pads Usually designed for engineers or draftsmen, these pads have vertical and horizontal lines forming grids in various sizes. Some are eight squares to the inch; some are ten, and others are five per inch. You must decide how tall to make your letters when using the gridded pads. Since each lower case letter should be five pen-widths high, you must find how many grids or lines most closely match that requirement for whatever pen you use.

Each of these three gridded sheets has a different number of lines per inch. Each can be used for practice or actual work to be later reproduced. If the lines are printed in blue, they won't copy.

Some gridded pads have non-reproducible blue lines. If you use a pad with these lines, for work that will later be photostated and reproduced, you won't need to worry about the lines showing up on the printed pieces. The printer's camera drops out the blue lines when copying the calligraphy.

If you're drawing your own guidelines on un-printed paper, you'll do it faster and more accurately by using **The Ken Brown GUIDELiner®.** You merely select the sets of lines matching the pen you're using and copy the spacings from the template directly onto your paper. This template takes all the guesswork and time-consuming measuring out of drawing perfectly spaced guidelines. See more about the **GUIDELiner®** in the Layout section of this book.

Papers for Originals

Carefully choose the paper you use for important calligraphy that will be framed or given as gifts. Even with compatible pens and ink, the wrong paper can ruin your efforts.

<u>Typing Bond</u> For quick informal pieces, a good quality typing bond is fine. Remember that typing papers have a manufacturer's watermark that may be distracting to your calligraphy. Check its position by holding the paper up to the light; if it's too predominant, use another portion of the paper for your lettering.

Also, typing paper is subject to curling and stretching due to humidity changes. For those two reasons, don't put your important work on paper designed for the typewriter or copy machine. If you do use bond, test both sides; one will take ink better than the other. This holds true for most papers.

<u>High-quality stationery</u> High rag-content papers available at stationery stores are excellent for calligraphy. You'll find a good assortment of colors, textures, and weights. Again, humidity will effect the piece so, if stability is important, leave stationery for something less than your calligraphic masterpieces.

<u>Parchment paper</u> Some are good and some are awful. The good ones dress up and give so much character to your finished piece. The bad ones are either so porous that your ink will bleed and feather, or so slick the pen won't grab the surface, but will skip across. Several colors are available in the good and bad. When you find a good parchment paper to combine with complementary colors of ink, your originals have an added richness over other paper stocks. The key to success here is testing to get the right paper and ink combinations for maximum compatibility.

Parchment papers are great for awards, certificates, poems, congratulatory messages, invitations, and other special presentations and greetings.

<u>Genuine parchment</u> Actual parchment is specially treated calf skin. It's expensive and is generally used only for very ornate and elaborate works. It can be obtained through a limited number of suppliers of high-quality art materials.

<u>Two-ply board</u> This board is about the thickness of a manila file folder. Its surface is smooth, yet has just enough texture for the pen to glide easily. It will render sharp, crisp strokes and will resist humidity changes much better than paper.

<u>Illustration board</u> This board is available from several manufacturers offering a variety of thicknesses, surface textures, and intended uses. When your project is to be displayed, with or without matting or framing, and when durability and stability are important, use a board that works well with your particular pens and inks. Visit your local frame shop and ask for some scraps of mat board. Often, that's the best source for a wide range of choices. If you buy some full or half sheets from the framer, the owner will likely give you a pile of scraps and remnants, from prior framing projects, at no charge. You'll probably find many of them are large enough for many of your lettering jobs.

<u>Illustration board with 100% rag surface</u> My personal favorite in this category is the No. 310 Medium Weight, *cold press* surface manufactured by Crescent. It can be found at virtually any art supply or frame shop.

Its surface has a slight roughness that takes the ink better than *hot press* which has a slick, smooth finish.

<u>Watercolor paper</u> There are only two reasons you should consider using stock designed for watercolor. Use it only if you plan to incorporate a watercolor painting with your calligraphy, or, if you want your lettering to have a uniformly ragged look along the stroke edges.

A SPEEDBALL® C-0 nib, approximately 3/16" wide, was used on heavy watercolor paper to achieve the ragged effect in these characters.

Most watercolor papers have a bumpy texture. If you use a narrow, small nib, you may not see these skips. A wide nib will glide across the rises in the paper, not allowing the entire point to touch the 'valleys' of the paper. Ink will only be applied to the higher portions of the surface. It can be a attractive effect. The wider the nib, the more dramatic and visible you textured letters will become.

<u>Clay-coated stock</u> Without exception, my favorite surface for calligraphy is the heavy, bright white, slick paper used for annual reports, fancy restaurant menus, and expensive brochures. I use it so much because much of my work is camera-ready and this surface gives such sharp, crisp detail to every stroke. It's not suitable for any other kind of calligraphy because the finish is so slick that you cannot draw penciled guidelines. Still, it takes ink beautifully from any pen.

When I use this stock, I use non-repro, fine-line, blue markers for guidelines. The slick paper will take the marker and since the camera doesn't see the lines, they don't have to be removed when I've finished lettering. I've used this paper for years and, although it's not designed for calligraphy, in my opinion and experience, it works as though that is its <u>only</u> purpose. Ask your local commercial printer or paper wholesaler for a sample. It's available in several different brand names and weights from various paper mills. Get a sample and try it for the next job you do to be reproduced by a commercial printer.

MISCELLANEOUS ITEMS

To be adequately equipped, your calligraphy workroom, studio, kitchen table, place in the garage or attic, or wherever you work, should have the basic items. The following is a list of things that will make you more efficient and make doing calligraphy more fun:

<u>T-Square</u> A long straightedge that slides along the side of your drawing board or table for drawing horizontal guidelines and for keeping your paper square on the board or table surface. It's also used as a base for sliding triangles so lines and angles can be accurately drawn.

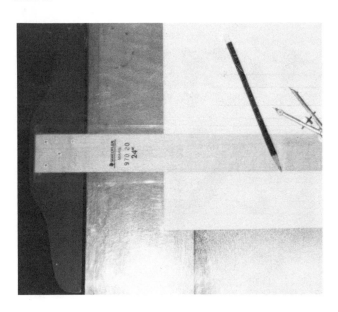

This is a T-square used for drawing guidelines as it slides along the left side of the drawing board.

<u>Parallel bar</u> A professional device that hooks to your drawing board with cables. It's just a glorified t-square.

<u>Drafting machine</u> An even more glorified t-square with vertical and horizontal rulers that stay square, or at any selected angle, no matter where you move the machine on the table. See examples in the photos on the *Drawing Boards* page of this book.

<u>Ken Brown GUIDELiner®</u> A template for quick layout of guidelines for various pens, without the need for repetitive measuring.

<u>Soft-lead pencils</u> For drawing guidelines. Use 2B or softer. Don't use the 'H' leads; they're too hard and you'll bear down to make them visible. The lines are then difficult to erase.

<u>Soft, white eraser</u> For erasing guidelines. Don't use red, or other abrasive erasers. They'll scratch your paper and ink.

<u>Electric eraser</u> For corrections when your lettering is done on heavy illustration board.

<u>Erasing shield</u> To isolate and restrict the specific area to be erased when using the electric eraser.

<u>Non-repro blue pencils and markers</u> For drawing guidelines on camera-ready pieces of work.

<u>Ultrasonic pen cleaner</u> For quickly and effectively cleaning badly neglected and clogged pen nibs.

<u>Pen caddy</u> A holder for sorting and organizing pens separated by size and color use.

<u>Small file drawers</u> For organizing papers and tools.

<u>Adjustable triangle</u> An aid for drawing lines at various degrees of slant off the horizontal or vertical when used with a t-square, parallel bar, or drafting machine.

CORRECTIONS

An indispensable tool for calligraphers, used for years by architects and draftsmen, is the electric eraser. When there's serious erasing to be done on a durable surface, this small hand-held machine is like a genie in a bottle.

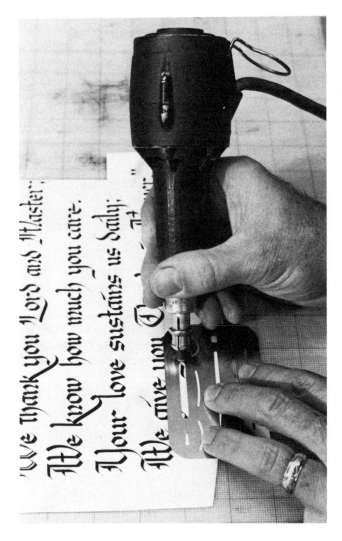

I've been using the same trusty old electric eraser for 25 years. The thin metal shield is for isolating areas not to be erased. I recommend the current model No. 2800 by KOH-I-NOOR RAPIDOGRAPH®.

Different grades of eraser elements are available. Some are for lead pencil on paper; some are for plastic leads on film, and others are abrasive for removing ink from other surfaces. If you want to correct errors on heavy board, get the abrasive elements.

With an erasing shield, you can usually remove very small areas of ink; the shield isolates and protects the portions of the lettering that should not be erased.

Even the best illustration board's surface will be changed when ink is erased with the abrasive element. If you must re-letter directly over the erased area, the surface may 'feather' and your new lettering may bleed. If possible, try to avoid lettering where you've erased; you may not have that choice if you're correcting a misspelled word.

You can resurface an erased area with an animal

bone or tooth prior to re-lettering. If the erased area is left blank, you may want to leave it alone. Do your best to concentrate and make no mistakes, but be prepared if you do.

If you make an error on a project that you've been hired to do as a perfect original, you have a couple of choices. First, if your correction is not too noticeable, tell your client or customer about the mistake. If agreeable, to save you doing it over, offer to deduct something from your fee and suggest that the piece be framed behind a piece of frosted, non-glare glass. That will probably hide the error and correction.

If it's a gift, and the change isn't obvious, you shouldn't even mention it.

Painful Lesson

I learned, with great anguish, to concentrate and avoid errors on commissioned originals.

In 1972 a doctor had agreed to pay me $100.00 to letter the 32-line poem, *If*, by Rudyard Kipling. The piece was to be about 24" x 30". I was almost 8 hours into the job, working in the middle of the 31st line. I had lettered the first 4 letters of *'everything'* when my 6-year old son came into my room and asked me a question.

When I turned back to my work, I finished the word, but I omitted the 'y.' Just as described above, I used my electric eraser to remove the 'thing', I inserted the 'y', and re-lettered 'thing.' I went on and completed that line and the last line. In the lower left corner I printed my credit line: "Calligraphy and mistakes by Ken Brown, February 6, 1972."

I immediately put up a clean piece of illustration board and did the entire piece again. That time I locked the door, took the phone off the hook, and dared anyone to come anywhere near me.

The doctor paid the $100.00 and never knew it was my second attempt. For that long, long day I netted about six bucks an hour. In the years since, the lesson has been worth thousands.

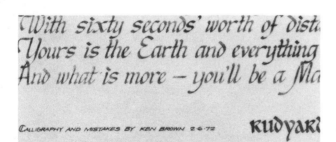

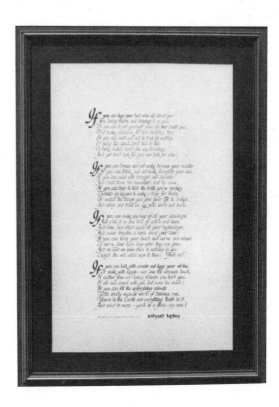

ABOVE: Though aged and faded, it's easy to see the variation in ink density in the word 'everything.'

RIGHT: The full original of IF was 28" x 38." It hangs just behind my drawing board as a constant reminder of the painful lesson.

The Ken Brown Calligraphy Handbook • © 1991 Ken Brown Studio

Drawing Boards

Some kind of drawing board will make learning and doing calligraphy easier and more pleasant. Comfort is so important for a relaxed approach to your practice or project. If you have adequate space, there's nothing wrong with working on the kitchen table or the breakfast bar. A flat surface can be quite comfortable, but a tilted board will save your back and allow greater reach to a larger area without having to stand or lean over. If you can't get a special, slanted board, then find a suitable substitute. Most office supply stores and all art retailers have drawing tables. Buy the best your budget will stand and avoid card tables, easy chairs, and laps.

1

2

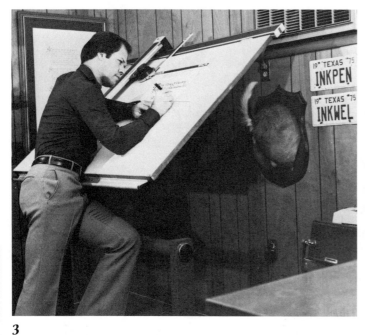

3

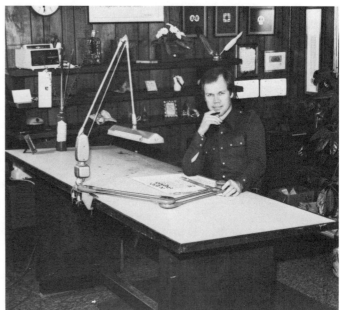

4

1 The lap board is an inexpensive, lettering surface. They're available at art stores or you can use a smooth piece of plywood or masonite from the lumber yard. Get a piece large enough to rest on your stomach or waist while the board leans against the kitchen table, desk, or bar. An ideal size is about 20" x 24."

2 A small drawing board of this design is available at any art store or office supply. It's adjustable for height and tilt. It's compact for easy storage. With a comfortable chair, this arrangement will increase your speed and efficiency.

3 This professional model is fully adjustable for height and tilt. It's equipped with a drafting machine, fully counterbalanced so the machine rests, ready to move anywhere on the table, at any table angle. This board is 37" x 60" and is used for large layouts. I usually stand while working at this board; I can reach a wider area and I'm more mobile.

4 Much of my work is done at a custom-made, oversized drawing board like those used by professional architects. It's a full 8' wide and 34" deep. It too is equipped with a drafting machine for guidelines and layout. The board is slightly tilted and is not adjustable. I do certificates and smaller pieces at this table. The wide area is great for reference materials and an assortment of pens and inks, always in easy reach. The fluorescent lamp is a must. Be sure your area is well-lighted.
NOTE: You can turn your lap board, or the paper on your drawing board ,at any angle but ALWAYS keep the 45° pen angle and your forearm parallel to the side of your work sheet.

24

The Workshop Section

The following pages, 26-39, are designed to quickly get you started building letters...and your confidence.

TEACHERS: If you are interested in establishing a class in calligraphy, familiarize yourself with the entire book, understanding the method it teaches, then have each student obtain his or her own personal copy of this book and the suggested tools. Guide them through the following 14 pages according to your own timetable. This section, covering just a few letters, works well for class plans as brief as only a few hours.

For longer class plans, develop your teaching and practice sessions around the Worksheets for both upper and lower case.

BEGINNERS: If you're a beginning student, working alone, use the suggested tracing paper and pens; concentrate your time and energies in this section. When you've gained some confidence, work your way through the remainder of the book and learn the entire alphabet. The secret to your success is dedicated, unfailing daily practice and a clear understanding of the 4 simple rules that govern this method used by hundreds of thousands around the world.

The Ken Brown Calligraphy Handbook • © 1991 Ken Brown Studio

The Rules

The following 4 rules will be the key to your success in learning calligraphy. This is what makes the Ken Brown method so foolproof and easy to learn. Etch these 4 rules in your mind; each one is vitally important. **Observe each rule every time you pick up a calligraphy pen**, whether for practice or the real thing. These rules apply to reservoir pens, dip pens, and calligraphy markers.

Study the photographs closely and be sure you understand what each shows. For the purpose of learning,

try each hand and pen posture to see the difference in the **CORRECT** and **INCORRECT** ways.

If you're experienced, or have learned another method, you'll probably find it more difficult to adapt to the hand positions shown. Believe me, if you're interested in ultimate control and consistency, you'll have *both* when these 4 rules become second nature to you.

Form good habits from the beginning and make these rules help make you a great calligrapher.

RULE 1: KEEP PEN POINT AT 45° ANGLE TO BASE LINE.

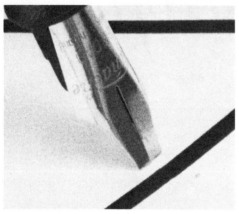

The <u>broad edge of the pen point</u> should be parallel with a 45° line. That's a line that splits the 90° angle where a vertical and horizontal line intersect. The horizontal line represents the BASE LINE of your lettering. The characters should sit uniformly on that line.

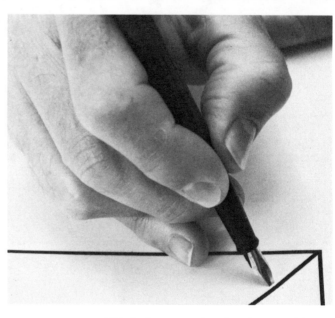

This is the correct hand and pen position to keep the 'cutting edge' of the nib aligned at 45° for every stroke of every letter.

The thick and thin parts of calligraphic letters occur because of the constant 45° angle of the pen point. These photos show the progression through a common stroke. <u>EVERY STROKE OF EVERY LETTER BEGINS AND ENDS AT A 45° ANGLE.</u> The pressure required to make the ink flow will vary with different paper surfaces. Bear down only as hard as necessary to activate and maintain ink flow. Hold the pen just tightly enough to maintain control. A 'death grip' will create tension, reduce circulation, and make a shaky hand. Relax and ALWAYS keep your pen point at the 45° angle.

TESTING YOUR PEN POINT ANGLE

This is an excellent way to test your pen angle:
1. Place tracing paper over these two boxes.
2. In first box: Place pen in <u>upper right corner</u> and draw a line to lower left. *LINE SHOULD BE AS THIN AS YOUR PEN POINT.*
3. In second box: Place pen in <u>upper left corner</u> and draw a line to lower right. *LINE SHOULD BE AS WIDE AS YOUR PEN POINT.*
If your lines aren't thin and thick as shown above, your pen is not at a 45° angle.

5

7

The Ken Brown Calligraphy Handbook • © 1991 Ken Brown Studio

RULE 2: HOLD PEN & FOREARM CORRECTLY.

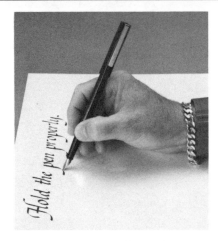

CORRECT POSITION
Hold the pen barrel or staff along the third section of your index finger, near the first knuckle. This allows only the knife edge of the nib to touch the paper.

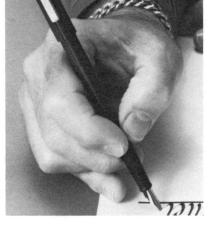

Front view of the hand and pen in the CORRECT POSITION. Notice how the pen barrel leans slightly to the calligrapher's right.

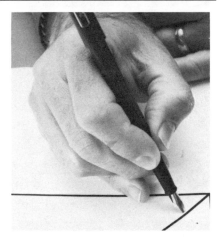

In the CORRECT POSITION, the pen point can be aligned with the 45° angle line. This pen point angle is a constant that should never change.

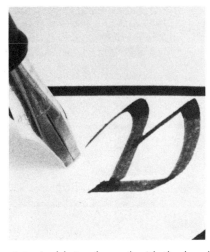

A typical letter formed with the hand in the CORRECT POSITION and the pen point at a 45° angle. Thicks and thins of the letter are in the right places.

Your forearm should _always_ be parallel, or in line, with the edge of the work surface. Regardless of table tilt or position of the paper on the table, always keep your forearm parallel to the edge.

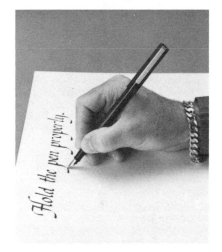

INCORRECT POSITION
NEVER hold any calligraphy pen as you would a ballpoint for regular handwriting.

TIP: IMPORTANT NOTE TO RIGHT _AND_ LEFT-HANDERS. As long as you observe the 4 rules, you can turn your paper at any angle on the work surface for better comfort or accessibility.

Ken is using a Panache™ Broad pen in all photos on this two page spread and on page 28.

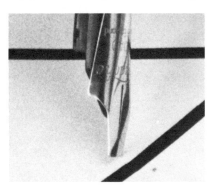

When held in the INCORRECT position, and the point is positioned at a 45° angle to the base line, only the left corner of the point touches the paper. Ink will not flow.

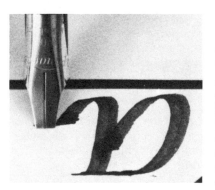

When held in the INCORRECT position, ink will flow only if the pen is rotated until its edge is parallel with the base line. Ugly letters happen with thicks and thins in the wrong places. Not only the pen's edge is touching, but some of the underside is also on the paper.

RULE 3: KEEP LITTLE FINGER EXTENDED.

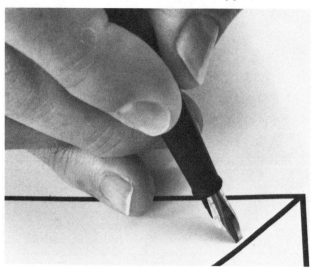

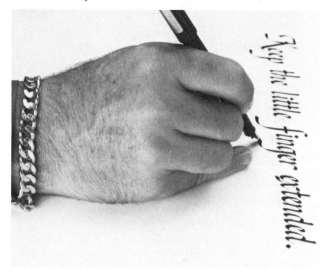

Control and stability are the most important assets in your learning process. ALWAYS keep your little finger extended. This will be awkward, but DON'T GIVE UP. It will soon become natural.

Here's how you do it:

(a) Pick your pen up and hold it as you would a ballpoint or pencil.

(b) *MOVE ONLY YOUR LITTLE FINGER, allowing it to straighten out. <u>Make the first joint of your ring finger rest on the first joint in your little finger.</u> Look at the photos. (REMEMBER RULE 2)*

When you are lettering, the heel of your hand should touch the paper from the wrist bone to the tip of the pinky. DO NOT let only the tip of your little finger touch the paper, while the rest of your hand floats in mid-air!

Most strokes and letters should be made with your hand locked in place; <u>MOVE ONLY YOUR THUMB, INDEX FINGER, AND MIDDLE FINGER.</u> Your 'anchored' hand will give you more stability. If you can't make an entire letter from the 'locked' position, or when large letters are made, let your hand lightly glide across the paper. The little finger remains extended, acting as a guide, or stabilizer, keeping an even pressure of your hand and pen on the paper.

Notice how you may be using your little finger as a stabilizer for other tasks in every day life.

Women usually rest their pinky against their chin as they put on fresh lipstick. That steadies the hand so they have control with the thumb, index, and middle finger they're using to paint their lips. Otherwise, the hand would not have enough control and the lip lines might look like Bozo.

When you tinker with small items, like using a tiny screwdriver to tighten the frames on your eyeglasses, you'll brace your pinky somewhere to give you precise control to enable the screwdriver blade to hit the hairline slot in the little screw.

This is the same reason for extending your pinky in calligraphy. With that extra anchoring point, you'll achieve smoother, more consistent strokes and letters and you'll quickly be able to spot the work of other calligraphers who insist on hiding that invaluable little finger in the palm of their hand.

The tip of the little finger should be in a constant position <u>just below and to the right of the pen point.</u> Be careful not to extend your pinky straight out, in line with the heel of your hand; it will get into the line above where you are currently lettering. If that line is still wet, your little finger will smear it. (This is why left-handers cannot extend the pinky in any position.)

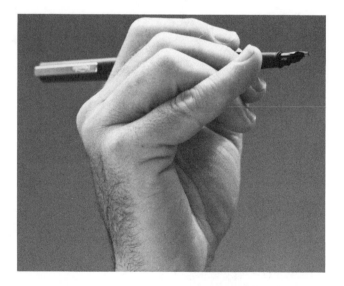

<u>The first joint of the ring finger rests directly on top of the first joint of the little finger.</u> When you assume this hand position, don't change the usual position of the middle and ring finger. However they are when you write with a ballpoint is the way they should be when you do calligraphy. You only change your pinky. Notice how it doesn't stick straight up, in line with the heel of the hand. It's bent down just enough to line up with the first joint of the ring finger.

CALLIGRAPHY IS NOT 'WRITTEN'

One of the great misconceptions about calligraphy is that you *write* the letters and words with special broad-edged pens. Since _calligraphy is a process of mechanically assembling various combinations of strokes to form total characters_, it must be disassociated with *writing* as in the regular cursive handwriting we do everyday.

PENS NOT DESIGNED FOR 'WRITING'

The construction and design of calligraphic broadpens will not permit the points to be *pushed* up or to the left; **PENS MUST BE PULLED DOWN OR TO THE RIGHT ONLY.** If you insist on writing in a continuous, unbroken motion, you'll need a ballpoint or other non-calligraphic instrument.

NOTE: You can *'write' with the calligraphy markers because their points aren't flexible and they won't splatter. However, treat them as you would flexible pens or you may develop bad habits that will carry over when using dip and reservoir pens.*

There are numerous books and instructors who teach the formation of the letters in continuous motions. They tell you to push the pen in any direction needed. That's risky. Ink splatters, paper tears, and poorly formed letters are the most you can expect if you treat these pens like ballpoints.

THINK OF IT AS DRAWING

You must mentally *shift gears* when you pick up a calligraphy pen. It's designed to *form* the letters, not *write* them. You are actually <u>drawing</u>, in a very controlled way, small single stroke marks that blend together and make letters. After a few practice sessions, when you've learned to faithfully follow the four rules, the urge to *write* with the broad-edged pen will leave you.

GOOD QUESTION

Here's a question, sure to be raised here: *If all strokes must go down or to the right, why does the pen go to the left at the end of the 's' stroke in illustration at right?* Answer: The pen can move left of center on downward strokes only. When the point reaches the place in the stroke, that to continue would be <u>pushing</u> the pen to the left, then the pen must be lifted off the paper.

To complete the bottom portion of the 's', a new stroke must be brought <u>from the left</u> to blend in with the tail of the first stroke. The bottom of the lower case 'f', is formed like the tail of the 's.'

To complete the 's' and 'f', the pen point would be placed at the <u>beginning</u> of the first strokes. Make the tops of each letter with a rounded stroke going down and right.

Where the strokes join is the thinnest part of the letter. **You cannot get satisfactory thin portions of your strokes when <u>pushing</u> the pen around the corners in a continuous motion.**

RULE 4 will mean the difference in whether your calligraphy is **<u>calligraphy,</u>** or merely handwriting done with a wide pen.

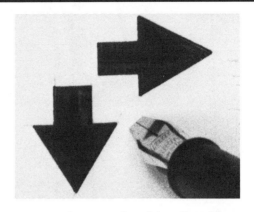

A graphic reminder of the allowable pen direction, regardless of what kind of calligraphic instrument you use.

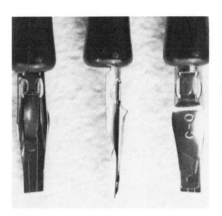

*Front, side, and back views of Speed-ball® C-0 dip pen showing the individual 'fingers' that make up the point. Some smaller nibs have only two sections. Gravity makes the ink flow from the tiny reservoir down through the slits and onto the writing surface. These slits make the points flexible, **never to be pushed up or to the left.***

As stated in RULE 1, every stroke of every letter begins and ends at a 45° angle to the base line. Notice how each of these partial letters aligns with the series of 45° lines. Regardless of the pen being used, the point should remain at this angle at all times.

The Ken Brown Calligraphy Handbook • © 1991 Ken Brown Studio

Left-Handers

Some of the world's best calligraphers are southpaws. If you're a lefty, don't despair. You will have a few slight disadvantages, but you *can* learn.

Often, it's difficult to find left-handed pens. Some manufacturers don't even offer them. It'll be easier to find dip pens for left-handers and occasionally stores will stock reservoir pens designed for you. With some slight adjustments, *you can work perfectly well with right-handed pens.* It may be a bit uncomfortable, but they work fine. In fact, I've known left-handers who

preferred right-handed pens, so don't let the scarcity of southpaw pens keep you from getting involved. Be patient and don't be pre-convinced you'll fail.

There are two exceptions in the four rules. **1.** As a left-hander, you cannot extend your little finger; it will smear the ink as your hand moves across the paper. **2.** If you are one who writes upside down, with your hand and wrist shaped like a hook, you must form every stroke in **reverse.** Your allowable pen direction must always be **up and to the left only.**

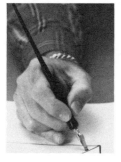 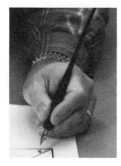

LEFT PHOTO: CORRECT POSITION for a right-hander.
RIGHT PHOTO: The southpaw's hand, in the CORRECT POSITION, would be a mirror image of the right-hander's. In this CORRECT POSITION, a right-handed pen, used by a left-hander, will not entirely touch the lettering surface; only the corner makes contact. NO INK WILL FLOW.

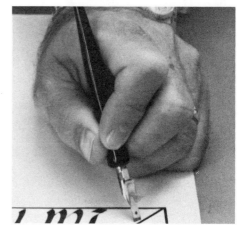

To have the entire knife edge of the point touch the paper so ink will flow, you must bend your hand down extremely, with your palm almost facing the lettering surface. Lettering with a right-handed pen in this position would break your hand _and_ your spirit.

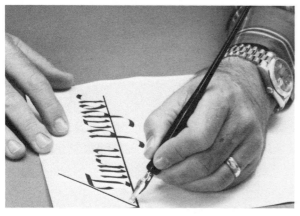

Left-handers, using a right-handed pen of any kind, should turn the lettering surface as shown. This will permit your hand to be in a more comfortable position and allow the entire edge of the pen point to touch the paper. It may take some time to get used to working toward your body instead of working left to right across the table. _NOTE: If you have a **left-handed** pen you won't have to turn the paper quite as much for the whole pen edge to contact the paper._

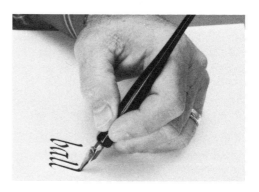

If you write with your hand in this position, you must make every stroke in the **reverse** direction from a right-hander. In this photo, the pen has just _finished_ making the lower case 'l.' To have started the letter at the top and finished at the bottom, like a right-hander, the pen would have been pushed, not pulled. In this position, you may be able to extend your pinky for added control. Experiment to see.

Development of The Method

When I sat down to write the first edition of this book in December, 1976, I had almost 16 years experience with calligraphy. In all those years I had never taught, and I never gave a thought about how I did calligraphy. Forming calligraphic letters had become as routine and automatic for me as tieing my shoelace, or buttoning a button. It was as though my fingers knew how but my brain didn't.

When I decided to create instructions for a book to teach others my method, I wasn't consciously aware of what the method really was. It seemed logical for me to to somehow, get out of my body, stand back, and look at what happened when I made letters.

I began with the lower case Chancery Cursive alphabet

used throughout my work....the same letters now used in this book. I went into a kind of slow motion mode and looked closely at every pen movement and every stroke of every letter.

That's when I became aware that I did all the things in the 4 rules each time a made a letter. Those 4 rules, noticed for the first time, were the reason I **formed** each letter, stroke by stroke. Since I could not **write** the letters, with the pen going just any direction as in handwriting, I had to build the letters with only a few common strokes that kept repeating throughout the alphabet.

Here is a close look at the first 5 letters to show how my breakdown of the alphabet began.

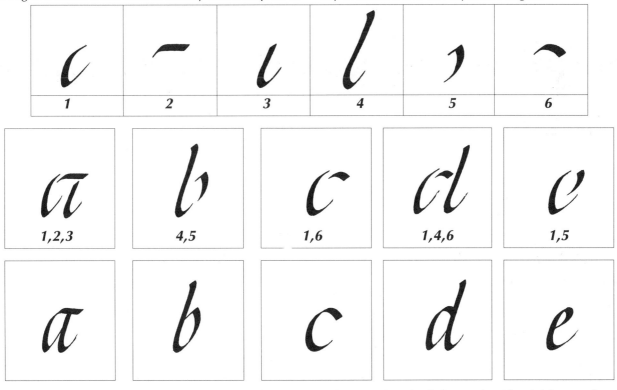

| 1 | 2 | 3 | 4 | 5 | 6 |

| 1,2,3 | 4,5 | 1,6 | 1,4,6 | 1,5 |

I made the first stroke of the 'a' and put it into the box above; I numbered it **stroke 1.** *The next piece formed the top of the letter and it became* **stroke 2.** *The third piece made the back of the letter; it became* **stroke 3.**

The 'b' needed a tall beginning piece, so I added it to the box above and numbered it **stroke 4.** *The second part became* **stroke 5.**

The 'c' started out exactly like the 'a', so I used **stroke 1** *again. To complete the top of the letter I used a new piece; it was added to the box and numbered* **stroke 6.**

The 'd' also started with the same part as the 'a' and 'c' so I used **stroke 1** *again. The second part of the 'd' was exactly like the first part of the 'b', so I used* **stroke 4.** *To fill in the gap, I used a shortened* **stroke 6.**

The 'e' began the same as the 'a', 'c', and 'd', so I used **stroke 1.** *The other part of the 'e' was the same as the second part of the 'b' so I used* **stroke 5** *with a slight change in shape.*

I continued through the entire alphabet, adding each letter and using some strokes again and again, while adding a few new ones along the way. It took 6 strokes to make the first 5 letters. I had to add only 8 more strokes to create 21 more letters. So.....with this method, it takes only 14 different single-stroke motions

to produce all 26 letters in this lower case alphabet.

On page 43 you'll see each of the 14 strokes and 26 letters. It's as simple as that. Learn 14 common strokes and their relationship, and you can do the same Chancery Cursive alphabet that I learned through literally years of trial and considerable error.

Starting to Learn

If you're just beginning the learning process, these are the first exercises in this book to involve you, pen-in-hand. Be sure you understand the rules and the concept of this teaching method, all on pages 26 through 31. FOLLOW THE RULES. Set a discipline for yourself and be patient. It will seem unnatural and awkward for a while but, given the time and practice, it will become second nature.

The instructions on this and the next three pages are more detailed than in following sections. You'll use larger pens to more clearly show contrasting thicks and thins. By the time you're working on later pages, with smaller pens and fewer instructions, your level of confidence and understanding will be higher; these next few exercises will help you see and be more aware of the details.

Back to the discipline. While you're learning, devote a minimum of 30 minutes daily for practice. If your routine is interrupted by travel or other distractions away from home, take the book, a couple of pens, and some tracing paper with you. Get up 30 minutes earlier or go to bed half-hour later. The more you practice the better you'll be.

It's just like all those folks who got to Carnegie Hall.

INSTRUCTIONS:
Trace the three sample strokes, then fill the rest of the space with the same stroke without tracing.

Check 45°
pen angle
here

Suggested Hunt Manufacturing Co. pens: Panache™ Broad, Elegant Writer® Broad or Speedball® C-2 + Bienfang® 100 Tracing Paper /

stroke 1

1. ARE THE FIRST 3 RULES ACTIVATED?
2. Start with right edge of pen just below top guideline.
3. Sweep down, to the left, keeping the stroke round.
4. Just as it touches the bottom guideline, make a round sweep up to the right.

5. Lift your pen off the paper as you finish the stroke.
6. Stroke should stop about half-way up the height of the letter.
7. Pen should stop in mid-air. NEVER end the stroke with pen on paper on this stroke.

stroke 2

1. Start just below the top guideline and move up with a smooth turn to follow STRAIGHT along line.

2. DO NOT PUT DIPS AND WAVES in this stroke.
3. At the end of the stroke, stop with pen on paper.
4. Do not lift the pen while it's still in motion.

stroke 3

1. Place right corner of the pen on the top guideline. Make the stroke straight down one of the angled guidelines.
2. Just before it touches the bottom line, begin a smooth turn so the bottom of the stroke barely touches the line. Sweep the pen upward, to the right.

3. Lift your pen off the paper as you finish the stroke.
4. Pen should stop in mid-air. NEVER end with pen on paper when making this stroke.

Use the suggested materials, or their equivalents, and TRACE the exercises. DON'T MARK DIRECTLY ON THE BOOK'S PAGES.

Check 45°
pen angle
here

Try assembling strokes 1, 2, & 3 to make the complete 'a.'

1. ARE THE FIRST 3 RULES ACTIVATED?
2. Make stroke 1 as shown earlier.
3. Place pen point just on the tip of the start of stroke 1.
4. Make the upward motion for stroke 2, with a smooth turn, then follow along the top guideline.
5. Stop WITH PEN ON PAPER at the end of stroke 2, then lift STRAIGHT UP.

6. Begin stroke 3 just to the left of the end of stroke 2.
7. Bring stroke 3 straight down one of the angled guidelines and barely touch the ending of stroke 1. Sweep up with a smooth turn at the bottom guideline.
8. Lift pen quickly off the paper at the end of the stroke which should come half-way up the height of the letter.

Trace these complete letters and make others on your own.

The properly formed letter 'a' should be not quite as wide as it is tall. You should be able to draw two parallel lines through the ends of strokes 1 and 3. There should be a small overhanging portion of stroke 2. There should be a small triangle formed by the ending of stroke 1 and the bottom of stroke 3.

stroke 4

1. ARE THE FIRST 3 RULES ACTIVATED?
2. Place pen point with right corner just touching the top guideline.
3. Start with a slight bend, then follow straight down an angled guideline.
4. As the pen nears the bottom line, begin a smooth turn to the right and sweep upward.
5. Lift pen quickly and end the stroke half-way up the guideline.
6. Pen should stop in mid-air to provide a thin, hairline end to the stroke.
7. NEVER end this stroke with pen on paper.

stroke 5

1. Start stroke just below the top guideline. With a thin line, go up until the right corner of the pen touches the line.
2. Without lifting the pen, sweep down and to the left with a round shape to the stroke.
3. Lift the pen quickly as you get about 2/3 the way down.

> **TIP:** *When your hand gets tense or tired, stop. Lay the pen down, drop your hand to your side and shake it out a few seconds. Flex your fist several times. DON'T keep a death grip on the pen. Hold it just tightly enough to maintain control.*

> **TIP:** *Be absolutely certain that you observe RULE 2. Keep the pen along the third section of your index finger. Always keep THE ENTIRE PEN POINT...CORNER TO CORNER...touching the paper.*

The Ken Brown Calligraphy Handbook • © 1991 Ken Brown Studio

Check 45°
pen angle
here

Try assembling strokes 4 & 5 to make the complete 'b.'

1. ARE THE FIRST 3 RULES ACTIVATED?
2. To make stroke 4, place pen point with right corner just touching the top guideline, or start below the line as shown in the example.
3. Start with a slight bend, then follow straight down an angled guideline.
4. As the pen nears the bottom line, begin a smooth turn to the right and sweep upward.
5. Lift pen quickly and end the stroke half-way up the guideline.
6. Pen should stop in mid-air to provide a thin, hairline end to the stroke.
7. Start stroke 5 from inside stroke 4. Move up until the right corner of the pen touches the top guideline, then make a round stroke down and to the left. When it joins the end of stroke 4, lift your pen straight up.

Trace these complete letters and make others on your own.

The properly formed letter 'b' should have the slight bend at the top, then be perfectly straight until stroke 4 curves at the bottom guideline. Stroke 5 should connect with stroke 4 at about the 'four o'clock' position and that connection should be very thin.

stroke 1

Make a line of stroke 1 again, exactly as instructed on page 32.

stroke 6

1. Start stroke just below top guideline.
2. Make a smooth arc letting the top of the arc just touch that line.
3. Continue down to the right and stop stroke where shown.
4. STOP your pen on the paper and lift straight up.

Try assembling strokes 1 & 6 to make the complete 'c.'

1. ARE THE FIRST 3 RULES ACTIVATED?
2. After stroke 1, start stroke 6 with the pen point touching the beginning of stroke 1.
3. Carefully match the joining part of the two strokes so the connection cannot be seen.

Trace these complete letters and make others on your own.

The properly formed 'c' has a smooth, round shape on the left side. Stroke 1 and 6 should be perfectly joined with a very thin connection.

NOTE: USE SAME PENS ON NEXT PAGE.

The Ken Brown Calligraphy Handbook • © 1991 Ken Brown Studio

Your First Sentence

With the completion of the previous three pages, learning to make **strokes 1 through 6,** you are now ready to calligraph your first sentence. Although it's a somewhat meaningless string of words, they are made up from only those 6 strokes. It will give you the feel and satisfaction of bringing the pieces together.

After you've done this page, carefully study the SPACING instructions on the next two pages, then try lettering the sentence again. I bet you'll do better the second time around.

INSTRUCTIONS

1. **Trace each set of 3 sample strokes, then make several more on your own.**
2. **Study the 'exploded' letters in the sentence.**
3. **Trace the strokes in the exploded sentence; notice the order of the strokes and how they should connect.**
4. **Calligraph the sentence, on your own, in the set of blank guidelines below. CONNECT the strokes; DO NOT repeat the exploded view.**

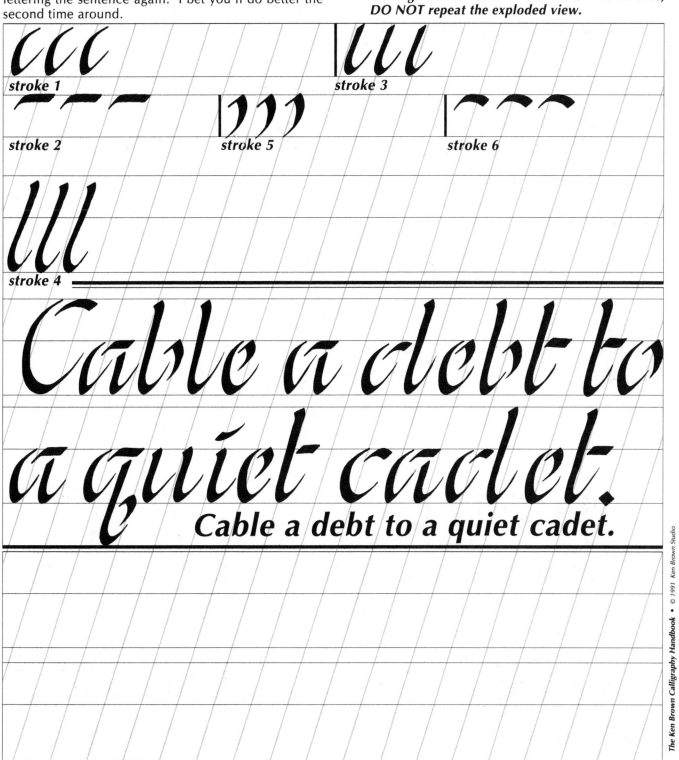

stroke 1

stroke 3

stroke 2

stroke 5

stroke 6

stroke 4

Cable a debt to a quiet cadet.

The Ken Brown Calligraphy Handbook • © 1991 Ken Brown Studio

Spacing

Spacing can make you or break you. I get letters every day from calligraphers whose calligraphy is marvelous, but their spacing is deplorable.

No matter how many swashes and swirls you learn to make, if your spacing is uneven you're still in the minor leagues. In the beginning, you'll be concentrating on so many rules and strokes that the placement of those strokes and letters next to other letters will get lost in the shuffle.

Much of good spacing is the ability to recognize letter and word relationships that are visually pleasing. Study what you've done so far. Does your spacing look like any of the examples below? Notice spacing in magazine ads, posters, and greeting cards where calligraphy or other script is used.

When I teach workshops, I review the **WIDEST, NORMAL, NARROWEST,** rules below. They're good to remember, but the most effective way to achieve consistently proper spacing, **almost automatically**, is to make great serifs....those skinny endings on many strokes.

When you learn to quickly lift the pen to get the serif, merely let the next letter touch the serif you just made. Some letters have no serifs; you'll have to learn, from practice and study of other calligraphy, how close together or far apart to place some letter combinations. Page 37 shows the importance and the ease of creating the proper serifs to help make good spacing happen as you work along.

Keep pens clean.

These letters are much too close together. The words are readable, but poorly spaced. I've had long names on diplomas with short lines where there was no choice but to pack them in this way.

Practice makes perfect.

This example is worse because it's inconsistent. There is _never_ an occasion where this kind of spacing is acceptable.

Good spacing or Bad?

BAD! If you have this much space, go to a bigger pen. The most graceful, well-made letters in the world are worthless when you can drive a truck between them.

Good spacing is easy.

It certainly is when you're constantly aware of the placement of **every** letter you make. Compare the letters in this example with the rules below. Notice how the serifs connect the letters in the word spacing.

poodle

You cannot **mechanically** space letters within a word. An 'l' takes much less room than a 'd.' When you assign an equal space for each letter this is what you get.

poodle

NARROWEST · WIDEST · NORMAL

This is a good example of each rule used in a single word.

WIDEST · NORMAL · NARROWEST

The WIDEST space goes between two straight characters such as a 'd' next to an 'l'. The NARROWEST space goes between curved letters such as an 'o' next to another 'o.' A NORMAL space is between a straight and a curved letter, such as an 'l' next to an e'.

between words

The space between words should be the amount of space taken by a lower case 'o.'

Calligraphy

The first stroke of the second letter is begun so that it will barely touch the end of the capital 'C.'

A nice finishing serif at the end of the 'a' provides a connecting point for the 'l'. Its serif gives the connection for the next 'l'. The 'i' ties to the 'l' and the 'g' ties to the 'i'.

The 'r' has no serif to snug up to on the left. Take a moment and remember that you have two **vertical** elements with the 'g' and 'r' side by side.

The 'r' has no serif on the right; in fact there is <u>nothing</u> on the right side. When you make the 'a', come in close; part of the 'a' should actually be under the top part of the 'r'. Be careful not to let the 'a' touch that part of the 'r'.

The 'p' will tie to the serif of the 'a', but provides no serif for the following 'h'. You'll have 'normal' spacing between the 'p' and 'h' since there is a **curved** letter next to a **straight** one.

The 'h' should provide a good serif for the first stroke of the 'y' to tie to.

When all connections are made like these you have great spacing.

Suggested Hunt Manufacturing Co. pens: Panache™ Broad, Elegant Writer® Broad, or Speedball® C-2 + Bienfang® 100 Tracing Paper

Check 45° pen angle here

ABOVE: Letter the word 'Calligraphy' and pay close attention to how you space the letters. Let the uniform serifs add clarity and visual appeal to your work.

Slide your tracing paper around and letter the word several times, using these guidelines. Keep looking and comparing yours to the sample above.

BELOW: Now that you have a better understanding about spacing, try the 'Cable a debt...." sentence again. If you get lost, look back on page 35. Do it as many times as necessary to make the letters connect as they should.

Date and save this and all your other tracing paper practice sheets. Store them away and look at them periodically to see your progress. It will be like looking at last year's photo of this year's kid.

The Ken Brown Calligraphy Handbook • © 1991 Ken Brown Studio

Ken Brown's
Old English

Lower Case

For a change of pace, and to tease you a bit with a totally different style of calligraphy, here is a sampling of my Old English in upper and lower case.

You'll enjoy offering a choice of lettering styles to other people who may want your work. It'll also be good to know Old English for those formal occasions such as lettering awards, certificates, proclamations, and title pages in family Bibles.

You'll find this to be no more difficult than the cursive. Just be sure to observe all the rules for hand and pen position and follow the vertical guidelines for keeping your strokes and letters standing uniformly.

Put tracing paper over these two pages and trace the strokes and letters just as you've been doing with the Chancery Cursive.

For the complete alphabets and more on this style of calligraphy, ask your dealer for **The Ken Brown Guide to Old English** from **HUNT MANUFACTURING CO.** If not available locally, order it from The Ken Brown Studio.

Suggested Hunt Manufacturing Co. pens: Panache™ Broad, Elegant Writer® Broad, or Speedball® C-2 + Bienfang® 100 Tracing Paper

Check 45° pen angle here

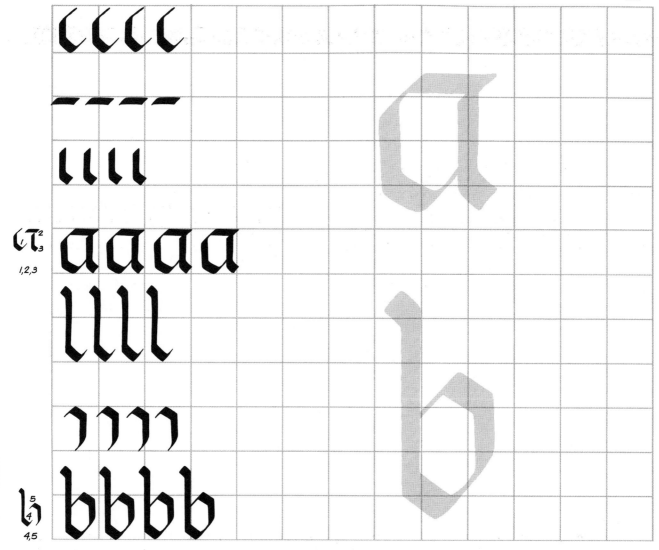

Check 45°
pen angle
here

Suggested Hunt Manufacturing Co. pens: Panache™ Broad, Elegant Writer® Broad, or Speedball® C-2 + Bienfang® 100 Tracing Paper

A
1,2,5,3,4,1

B
1,6,5,3,7,7,5

C
8,3,9

D
1,6,5,3,7,5

E
1,6,3,9,10

F
1,6,5,3,9

The Ken Brown Calligraphy Handbook • © 1991 Ken Brown Studio

Ken Brown's Chancery Cursive

Lower Case

This alphabet evolved over several years of my development. It's not unique in form or shape; but it is unique within itself. You would not find an alphabet in any book or any place whose strokes and letters would precisely match all my 14 strokes and 26 letters.

When I began in 1961, I experimented with all kinds of letters. I'd see one that I liked somewhere and I'd learn to make it. I 'collected' the ones that were appealing, and, over the years, developed this simple, easy-to-read, easy-to-make group of cursive characters.

If you're a beginner, work hard to learn this alphabet as a foundation. If you already have some experience, see what parts of these strokes and letters you might add to your own style. Understand how the strokes go together to make the finished characters. BUT DON'T STOP HERE!

This is not the only calligraphic alphabet. Look around. Find others you like and, as I did, take what you like from different ones and create your own set of characters; they will have your own identity. Even if you try to precisely duplicate every one of these letters, you could not. Just as each one of us has a unique handwriting, each will have unique calligraphy.

Let this be your springboard. When you can make these as shown, get loose and do your own thing. Never stop experimenting in your work.

The Strokes

These 14 strokes, in various combinations, make up **Ken Brown's Chancery Cursive** lower case alphabet. Some slight variation in size or shape may be required of the same stroke in different letters.

The 'dot' on the 'i' and 'j' is optional. I usually use stroke 8; you may wish to put the 'dot' as shown.

1	2	3	4	5	6	7
8	9	10	11	12	13	14

Below are the letters made up of the 14 strokes. The stroke numbers under each character are listed in the order they're done.

The Letters

a	b	c	d	e	f	g	h	i	j
1,2,3	4,5	1,6	1,4,6	1,5	7,6,8,2	1,2,9,8	10,11	3,8	9,8,8

k	l	m	n	o	p	q	r	s	t
10,5,12	4	13,13,11	13,11	1,5	9,8,5,8	1,2,4,5	13,6	14,6,8	4,2

u	v	w	x	y	z
3,3	13,5	3,3,5	12,2,8	3,9,8	5,5,8

Worksheets

All 26 letters in **Ken Brown's Chancery Cursive** alphabet have been broken down, showing each stroke in each letter. Place a sheet of high-quality tracing paper over the *Worksheet*. Read the notes for each item before tracing.
(1) Make rules 1, 2, & 3, active.
(2) Trace the 3 samples at the beginning of each line.
(3) Make more without tracing in the remaining space.

Keep your strokes and letters the same size as the examples, and within the guidelines. Ignore the 'boxes' formed by the diagonal lines. Those slanted lines are for keeping your strokes and letters leaning uniformly.

IMPORTANT NOTE:
Complete letters 'b', 'd', 'h', 'k', 'l', and 't', are shown shorter than their individual strokes in the exercises. Make the complete letter as shown, or make it taller.
Try making them both heights to see which you prefer. This height is a matter of personal taste in most instances, however, available space usually dictates the height used.
The pen you use may not exactly match the widths of strokes and letters below. Don't worry if yours are slightly larger or smaller. If you use a different brand than suggested, select a pen that most closely matches these letters sizes.

Suggested Hunt Manufacturing Co. pens: Panache™ Medium, Elegant Writer® Fine, or Speedball® C-3 + Bienfang® 100 Tracing Paper

1	*ccc*	Start stroke just below top guideline. Bring curving stroke down to bottom line, then sweep up and lift pen quickly.	Check 45° pen angle here
2	*— — —*	Stroke begins just below top line. Bring up and straight across. At end, stop with pen on paper. Lift straight up.	
3	*lll*	Top right of stroke just touches top line. Bring down angled guide to bottom line. Sweep up. Lift pen at end.	
	aaa	Keep the little open triangle at the base of the 'a' by lifting the pen quickly as instructed above.	**Pen at a 45° angle?**
4	*lll*	Start with slight bend at top. Bring straight down angled guide to bottom line. Sweep up. Lift pen at end.	
5	*ʃʃʃ*	Start just below top line. Bring up to line, then make a curved stroke down and lift the pen quickly at end.	
	bbb	Blend the end of stroke 5 into the end of stroke 4. Where the strokes touch should be very thin.	**Pen barrel against your knuckle?**
1	*ccc*	Start stroke just below top guideline. Bring curving stroke down to bottom line, then sweep up and lift pen quickly.	
6	*‿ ‿ ‿*	Begin stroke just below top line. Curve up to just touch line. At end, stop with pen on paper. Lift straight up.	
	CCC	The beginning of stroke 6 starts from the beginning of stroke 1. The joining area should be very thin.	**Little finger out? Heel of hand on table?**
1	*ccc*	Start stroke just below top guideline. Bring curving stroke down to bottom line, then sweep up and lift pen quickly.	
4	*lll*	Start with slight bend at top. Bring straight down angled guide to bottom line, then sweep up and lift pen quickly.	
6	*‿ ‿ ‿*	Begin stroke just below top line. Curve up to just touch line. At end, stop with pen on paper. Lift straight up.	
	ddd	After strokes 1 & 4 are made, bring stroke 6 from the beginning of 1, into 4. Keep the little open triangle at the base of the 'd' by lifting the pen quickly as instructed above.	**Pen going down and to right only?**

The Ken Brown Calligraphy Handbook • © 1991 Ken Brown Studio

| 1 | CCC | Start stroke just below top guideline. Bring curving stroke down to bottom line, then lift pen quickly. | Check 45° pen angle here |

| 5 |))) | Start just below top line. Bring up to line, then make a curved stroke down and lift the pen quickly. **Keep a firm, but relaxed grip on the pen.** |

| | eee | Stroke 5 starts from the beginning of stroke 1; when used in the letter 'e', stroke 5 is slightly smaller than in other letters. Bring up to top line, then make curved stroke into stroke 1 |

| 7 |))) | Start just above top line. Curve down to straight along angled guide. Sweep to left and lift pen quickly at end. |

| 6 | ⌒⌒⌒ | Begin stroke in center of space. Curve up and make an arc. At end, stop with pen on paper. Lift straight up. |

| 8 | ⌣⌣⌣ | Begin in down motion, then sweep up to right and lift pen quickly at end of stroke. |

| 2 | — — — | Stroke begins just below top line. Bring up and straight across. At end, stop with pen on paper. Lift straight up. |

Save and date every practice sheet.

| | fff | The beginning of stroke 6 starts from the beginning of stroke 7. The joining area should be very thin. |
| | | As you complete stroke 8, and the pen touches the ending of stroke 7, lift the pen. The joining is very thin. |

| 1 | CCC | Start stroke just below top guideline. Bring curving stroke down to bottom line, then lift pen quickly off paper. |

| 2 | — — — | Stroke begins just below top line. Bring up and straight across. At end, stop with pen on paper. Lift straight up. |

| 9 |))) | Right corner just touches top line. Bring straight down angled guide and sweep to left, lifting pen quickly at end. |

| 8 | ⌣⌣⌣ | Begin in down motion, then sweep up to right and lift pen quickly at end of stroke. |

| | ggg | Keep the little open triangle at the base of the 'g' by lifting the pen quickly as instructed above. **Pen point at 45° angle?** |
| | | As you complete stroke 8, and the pen touches the ending of stroke 9, lift the pen. The joining is very thin. |

| 10 | /// | Begin with slight bend at top. Bring down angled guide ending with slight bend as stroke touches bottom line. |

| 11 | ııı | Stroke 11 begins inside stroke 10, just below the guideline. Keep both 'legs' parallel. |

Holding the pen against your knuckle?

| | hhh | Begin stroke 11 from inside stroke 10, just below top line. Curve up to touch line, then straight down to bottom line. Sweep up and lift pen . |

The Ken Brown Calligraphy Handbook • © 1991 Ken Brown Studio

3	*ℓℓℓ*	Top right just touches top line. Bring straight down angled guide to bottom line. Sweep up. Lift pen at end. **Check 45° pen angle here**
8	*◡ ◡ ◡*	Begin in down motion, then sweep up to right and lift pen quickly at end of stroke.
	iii	Make the 'dot' on the 'i' with a with a dot as shown, **or** with a smaller stroke 8 than the one at the end of the 'f' and 'g'. **Is your little finger out?**

9	*/// *	Right corner just touches top line. Bring straight down angled guide and sweep to left, lifting pen quickly at end. **Pen going down and to right only?**
8	*◡ ◡ ◡*	Begin in down motion, then sweep up to right and lift pen quickly at end of stroke.
	jjj	Make the 'dot' on the 'j' with a with a dot as shown, **or** with a smaller stroke 8 than the one at the end of the 'f' and 'g'. Lift the pen at the end of stroke 8, just as the pen touches the end of stroke 9.

10	*///*	Begin with slight bend. Bring straight down angled guide ending with slight bend as pen touches bottom line. **Are you using the correct size pen?**
5	*ᴊᴊᴊ*	Start just below top line. Bring up to line, then make a curved stroke down and lift the pen quickly at end.
12		Make straight, down and to the right. Just as pen touches bottom line, sweep up and lift pen off paper.
	kkk	Assemble individual strokes as shown

4	*ℓℓℓ*	**Is your pen point at a 45° angle?** Start with slight bend at top. Bring straight down angled guide to bottom line. Sweep up. Lift pen at end.
	ℓℓℓ	

13	*///*	Top corner just touches top line. Begin with slight bend, then bring straight down. End with bend at bottom line. **Are you staying inside the guidelines?**
13	*///*	Same as stroke 13 with added portion at top. Begin just below top line. Curve up to touch line. Bring straight down. End with bend at bottom line.
11	*iii*	Begin stroke 11 from inside stroke 10, just below top line. Curve up to touch line, then straight down to bottom line. Sweep up and lift pen .
	mmm	Make each stroke as above. Assemble as shown with same space between 'legs' of finished letter.

The Ken Brown Calligraphy Handbook • © 1991 Ken Brown Studio

Check 45° pen angle here

13	*lll*	Top corner just touches top line. Begin with slight bend, then bring straight down. End with bend at bottom line.
11	*lll*	Begin just below top line. Curve up to touch line, then straight to bottom line. Sweep up and lift pen at end.
	nnn	Make strokes as shown above. Begin stroke 11 touching 13. Make sure 'legs' of letter are parallel.

Pen barrel against your knuckle?

1	*ccc*	Start stroke just below top guideline. Bring curving stroke down to bottom line, then lift pen quickly off paper.
5	*))) *	Start just below top line. Bring up to line, then curve stroke down and lift the pen quickly off the paper at end.
	ooo	Make stroke 1. Start stroke 5 at beginning of 1. Bring up to top line, curve down slowly; blend into end of 1.

Is your pinky out?

9	*lll*	Top just touches top line with slight bend. Bring along angled guide and sweep to left, lifting pen quickly at end.
8	*~ ~ ~*	Begin in down motion, then sweep up to right and lift pen quickly at end of stroke.
5	*)))*	Start just below top line. Bring up to line, then curve stroke down and lift the pen quickly off the paper at end.
8	*~ ~ ~*	Begin in down motion, then sweep up to right and lift pen quickly at end of stroke.
	ppp	Assemble as shown. Bring each stroke 8 in from left. Lift pen when 8 touches adjoining stroke.

Are you following angled guidelines?

1	*ccc*	Start stroke just below top guideline. Bring curving stroke down to bottom line, then lift pen quickly off paper.
2	*– – –*	Stroke begins just below top line. Bring up and straight across. At end, stop with pen on paper. Lift straight up.
4	*lll*	Begin with bend at top, then bring straight down angled guide. Sweep up. Lift pen at end.
5	*)))*	Start just below top line. Bring up to line, then curve stroke down and lift the pen quickly off the paper at end.
	qqq	Assemble 1,2,& 4 as shown. Slowly bring the end of stroke 5 into the end of stroke 4. Stop and lift pen.

Are you making pen go down and right only?

13	*lll*	Top corner just touches top line. Begin with slight bend, then bring straight down. End with bend at bottom line.
6	*^ ^ ^*	Begin stroke just below top line. Curve up to just touch line. At end, stop with pen on paper. Lift straight up.
	rrr	Make stroke 13. Start stroke 6 touching 13, just below top line.

Are you practicing 30 minutes daily?

14	∫∫∫	Begin just below top line. Curve left, then down and right at a 45° angle. Curve left and lift pen at end, just above line.

Check 45° pen angle here

8	⌐⌐⌐	Begin in down motion, then sweep up to right and lift pen quickly at end of stroke.

Keeping your forearm parallel to paper?

6	⌒⌒⌒	Begin stroke just below top line. Curve up to just touch line. At end, stop with pen on paper. Lift straight up.
	SSS	Make 14 first. Stroke 6 begins at the start of 14. Bring 8 in from left and lift pen when it touches end of 14.
4	lll	Start with slight bend at top. Bring straight down angled guide to bottom line. Sweep up. Lift pen at end.

Making strokes and letters like examples?

2	‾‾‾	Stroke begins just below top line. Bring up and straight across. At end, stop with pen on paper. Lift straight up.
	ttt	Make each stroke and assemble as shown. As in the examples, you may want to omit the 'dip' at the beginning of stroke 2.
3	lll	Top just touches top line and has slight bend. Bring down angled guide to bottom line. Sweep up. Lift pen at end.
3	lll	Top just touches top line and has slight bend. Bring down angled guide to bottom line. Sweep up. Lift pen at end.
	uuu	Two identical strokes joined at the end of the first. Be sure uprights are parallel.

Pen going down and to right only?

13	lll	Top corner just touches top line. Begin with bend, then bring straight down. Stop as pen touches bottom line.
5)))	Top corner just touches top line. Omit thin stroke that usually begins stroke 5. Bring curved stroke down to left and stop the instant it touches the base line. Pen stays on paper at stop.
	VVV	Strokes should meet precisely at bottom, forming a sharp point that just touches the bottom guideline.

Is your pen at a 45° angle?

3	lll	Top just touches top line and has slight bend. Bring down angled guide to bottom line. Sweep up. Lift pen at end.
3	lll	Top just touches top line and has slight bend. Bring down angled guide to bottom line. Sweep up. Lift pen at end.

Is your little finger extended?

5)))	Top corner just touches top line. Bring curved stroke down to left and lift quickly at end of stroke.
	www	Keep first two upright 'legs' parallel. Sweep the second one up and lift pen quickly. Bring stroke 5 into it; lift pen when 5 touches stroke 3.

TIP: *Contrasting thicks and thins, in the correct places, are the very essence of beautiful calligraphy. It's vitally important that you learn to lift the pen quickly on strokes with skinny endings known as 'serifs.' Practice all those strokes over and over. Be certain that your point is at a 45° angle at all times.*

12	Start just below the top line, moving up to touch it, then turn and make a straight stroke going down and to the right at a 45° angle. When stroke reaches bottom line, sweep up and lift pen.	Check 45° pen angle here
2	Stroke begins just below top line. Bring up and straight across. At end, stop with pen on paper. Lift straight up. **Little finger out? Heel of hand flat?**	
8	Begin in down motion, then sweep up to right and lift pen quickly at end of stroke.	
	After strokes 12 and 2, bring 8 in from the left. Stop pen as it comes in and touches stroke 12.	

3	Top right just touches top line. Bring straight down angled guide to bottom line. Sweep up. Lift pen at end.
9	Top just touches top line with slight bend. Bring down angled guide and sweep to left, lifting pen quickly at end. **Pen barrel against knuckle?**
8	Begin in down motion, then sweep up to right and lift pen quickly at end of stroke.
	Bring 9 down so it touches the end of 3. Uprights should be parallel. Bring 8 in from left to blend in end of 9.

5	Begin just below top line, then curve up to touch it. Continue thin portion stopping pen at bottom line.
5	Top starts just below top line. Move up to touch it, then a wide sweeping stroke to the right, then curve down and to the left.
8	Begin in down motion, then sweep up to right and lift pen quickly at end of stroke.
	Make two different sizes of stroke 5. Start the second one at the end of the first one. Bring stroke 8 in from left. Lift pen when it touches end of the second stroke 5.

Can you do all letters now without referring back to these pages?

Below are 3 sets of guidelines. See how many of all the letters you can remember and do without referring back to the Worksheets. In each set, the upper section is for ascenders and the lower is for descenders. Remember the rules.

The Ken Brown Calligraphy Handbook • © 1991 Ken Brown

Numbers

By now, you know how the strokes and letters work together. You should be able to quickly see how the numbers are developed using similar strokes as in the letters, As with letters, trace the numbers also, then make them on your own and even add your own ideas.

There are two sets of numbers compatible with Chancery Cursive. The first set will go with the lettering you're learning. The second set is a little more playful and less formal, but still Chancery Cursive.

Below are two additional sets; notice they're done vertically. I've also given you a traditional set and one much looser. Use these with your vertical cursive letters.

You may want to make numbers the same height as upper case letters, or you may prefer to make them the size of the lower case. Or.....you may even make them in-between. Experiment and see what you like.

Practice by lettering envelopes to the people you correspond with. If you don't write letters, send a card and address a fancy envelope to the local judge on his birthday. He might just forgive your next ticket for doing 40 in a 30.

But don't count on it.

Suggested Hunt Manufacturing Co. pens: Panache™ Broad, Elegant Writer® Broad, or Speedball® C-2 + Bienfang® 100 Tracing Paper

Check 45° pen angle here.

1234567890

1234567890

1234567890

1234567890

The Ken Brown Calligraphy Handbook • © 1991 Ken Brown Studio

Calligraphy by:

Practice sheet was done on this date:

• • to be saved and compared with my future work.

To obtain maximum benefit from this practice pad, consult THE KEN BROWN CALLIGRAPHY HANDBOOK and THE KEN BROWN GUIDE TO OLD ENGLISH for proper letter formation.

NOTE:

These two sample pages are from **The Ken Brown Calligraphy Practice Pad**, as seen on the Public Television series, **Ken Brown's Calligraphy for Everyone**. This is the most well-designed practice pad available anywhere. It has 32 pages, each specially created with differents sets of guidelines for **Elegant Writer®** Calligraphy Markers, **Speed-ball®** Dip Pens, and **Panache™** Reservoir Pens. It works with any other brand of pen as well.

There's no guesswork about drawing properly spaced sets of lines for whatever pen you're using. Each page tells the pens it's designed for. There are pages for both inclined and vertical letters.

Place a sheet of tracing paper over these pages and see how convenient it is to have properly spaced lines that match your pens. Daily practice with **The Ken Brown Calligraphy Practice Pad** will make your practice easier and your learning faster.

Ask your local art dealer for this special pad, available from **Hunt Manufacturing Co.**

Watch Ken use the pad on his Public Television instructional series. Consult local listings or ask the PBS tv station serving your area to air **Ken Brown's Calligraphy for Everyone.**

Elegant Writer® *Fine* **SPEEDBALL®** *C-3* **Panache™** *Medium*

This practice sheet has properly spaced lines for the following pen(s), or other pens of equal sizes:

©1989 KEN BROWN STUDIO, INC.

Calligraphy by:

Practice sheet was done on this date:

• • • to be saved and compared with my future work.

To obtain maximum benefit from this practice pad, consult THE KEN BROWN CALLIGRAPHY HANDBOOK and THE KEN BROWN GUIDE TO OLD ENGLISH for proper letter formation.

Elegant Writer® *Broad & Scroll* **SPEEDBALL®** *C-2* **Panache**™ *Broad & Scroll*

Ask your art supplier for other *KEN BROWN CALLIGRAPHY* materials including instruction books, kits, GUIDEliner layout template, and teaching videos. All Ken Brown products exclusively distributed by HUNT MANUFACUTURING CO., Statesville, NC 28677

This practice sheet has properly spaced lines for the following pen(s), or other pens of equal sizes:

Blessed are those who can give without remembering and take without forgetting.

©1981 Ken Brown Studio • Hugo, OK 74743 • Calligraphy by Ken Brown • Illustration by Gail Brown

Messenger

God, let me be a messenger
Of happiness, I pray.
A smile, a note, a phone call
To brighten someone's day.

The hours of life go swiftly;
There isn't time to wait.
I want to spread some happiness;
Too soon 'twill be too late.

—Ken Brown
©1984

The Ken Brown Calligraphy Handbook • © 1991 Ken Brown Studio

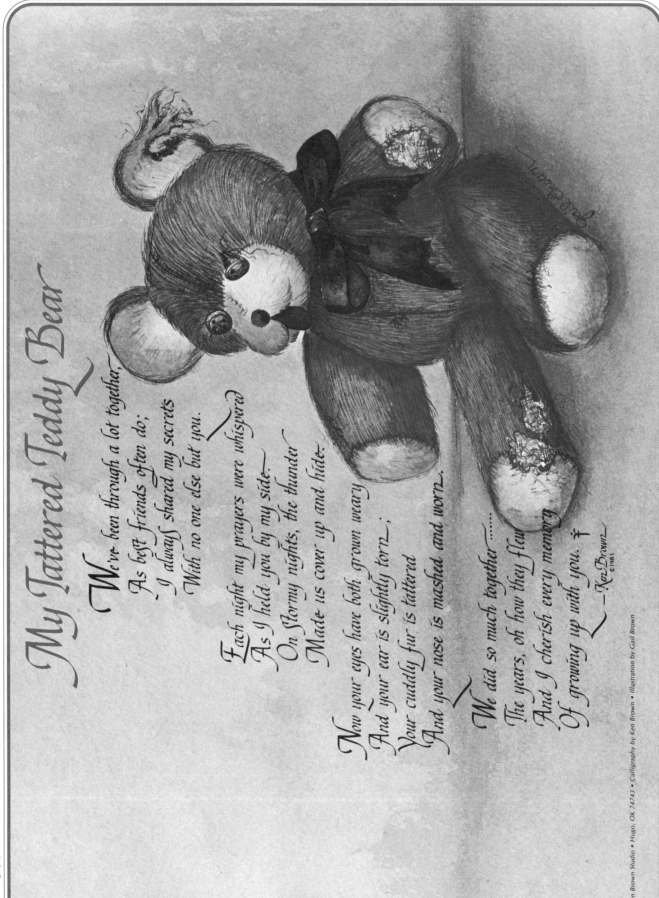

My Tattered Teddy Bear

We've been through a lot together,
As best friends often do;
I always shared my secrets
With no one else but you.

Each night my prayers were whispered
As I held you by my side.
On stormy nights, the thunder
Made us cover up and hide.

Now your eyes have both grown weary
And your ear is slightly torn;
Your cuddly fur is tattered
And your nose is mashed and worn.

We did so much together......
The years, oh how they flew
And I cherish every memory
Of growing up with you. ✝

—Ken Brown
©1983

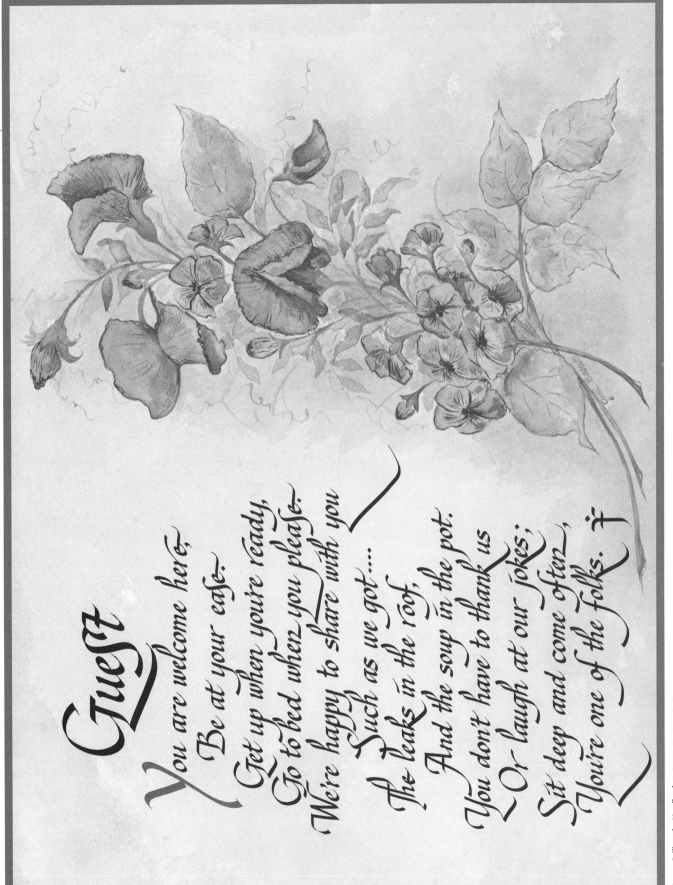

Guest

You are welcome here,
Be at your ease.
Get up when you're ready,
Go to bed when you please.
We're happy to share with you
Such as we got.....
The leaks in the roof,
And the soup in the pot.
You don't have to thank us
Or laugh at our jokes;
Sit deep and come often,
You're one of the folks. ✝

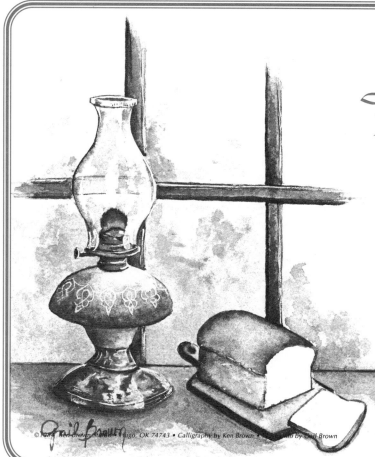

House Blessing

Bless the corners of this house,
And be the lintel blessed;
Bless the hearth and bless the board
And bless each place of rest.

Bless the door that opens wide
To stranger as to kin;
Bless the crystal windowpane
That lets the starlight in.

Bless the rooftree overhead,
And every sturdy wall;
Bless the love abounding here....
God bless us one and all!

Author Unknown

©1984 Ken Brown Studio • Hugo, OK 74743 • Calligraphy by Ken Brown • Illustration by Gail Brown

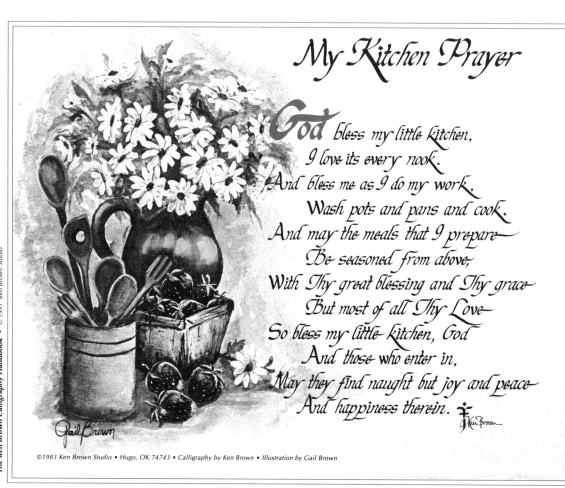

My Kitchen Prayer

God bless my little kitchen,
I love its every nook.
And bless me as I do my work.
Wash pots and pans and cook.
And may the meals that I prepare
Be seasoned from above,
With Thy great blessing and Thy grace
But most of all Thy Love
So bless my little kitchen, God
And those who enter in,
May they find naught but joy and peace
And happiness therein.

©1983 Ken Brown Studio • Hugo, OK 74743 • Calligraphy by Ken Brown • Illustration by Gail Brown

Ken Brown's
Chancery Cursive
Upper Case

These are the capital letters that I *collected* over the years. They're typical calligraphic letters but the alphabet, as a whole, is unique. Nowhere would you find another alphabet where every stroke and letter is *exactly* like these.

Even though these letters look more complicated, each having more strokes than most of the lower case characters, this alphabet has only 12 strokes, specifically numbered and identified for the upper case letters.

Learn these letters by tracing them and their common strokes. If you've already spent time practicing and learning the lower case letters, you'll find the capitals to be easy.

Make this your training ground; when you can make each letter without tracing or looking at these, begin to personalize them with your own creative changes.

The Strokes

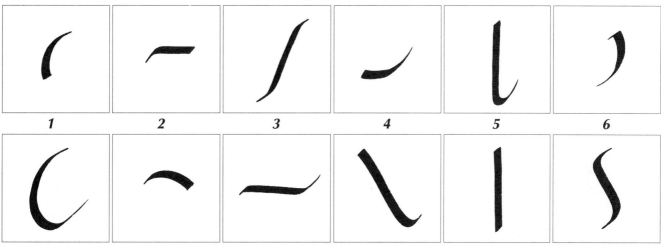

| 1 | 2 | 3 | 4 | 5 | 6 |

| 7 | 8 | 9 | 10 | 11 | 12 |

ABOVE: *These 12 individual strokes make up all the letters in* **Ken Brown's Chancery Cursive** *upper case alphabet.*

For the sake of simplicity, some of the strokes must be changed slightly in shape or size when used in different letters. The basic formation of the stroke is the same.

BELOW: *The complete letters are made up from the 12 strokes. Below each letter is shown the list of strokes and the order in which they should be made. Notice the similarity in many of the stroke orders.*

The Letters

A	B	C	D	E
2,3,4,5,2,1	2,3,6,6,9,1	7,8	2,3,6,9,1	2,3,9,2,1

F	G	H	I	J
2,3,4,2,1	7,8,2,3,4	2,3,4,5,8,2,1	3,4,1	2,3,4

The Ken Brown Calligraphy Handbook • © 1991 Ken Brown Studio

 2,3,4,6,10,1

 3,9,8

 2,3,4,11,11,5,1

 2,3,4,11,3,8

 7,6

 2,3,4,6,4,1

 7,6,10

 2,3,4,6,10,1

 12,8,4

 2,3,9,1

 2,5,5,1

 2,11,6,1

 2,11,11,11,8,1

 2,10,4,1,2

 2,5,3,4,1

 2,3,9,1

Friendship is the inexpressible comfort of feeling safe with a person, having neither to weigh thoughts nor measure words but pouring all right out just as they are, chaff & grain together, certain that a faithful friendly hand will take & sift them, keep what is worth keeping, and with a breath of comfort, blow the rest away. Ken Brown

Author unknown

Worksheets

These letters are 8-10 penwidths high. Let your personal taste and available layout space dictate how tall you make your upper case letters. Even though you should still....and always....keep your little finger extended, you'll have to move your hand slightly to create these longer strokes. **Where you can, keep your hand firmly planted on the paper, moving only your thumb, index, and middle finger to make the strokes.**

If you must move your entire hand, keep the little finger out to stabilize a smooth movement. Let the heel of your hand, and pinky, glide lightly across the sheet.

It's more important than ever to keep the pen barrel alongside your index finger. That allows the **entire** point to touch the paper, making it produce ink from corner to corner. If your strokes appear uneven in width, and if you have skips in the letters, you aren't allowing the entire point to touch the paper.

Don't write on these pages. Place tracing paper over them and do the following:

(1) **Make rules 1,2, & 3 active.**
(2) **Trace the strokes in the 'exploded' letter.**
(3) **Trace the whole letter, doing the strokes in the order shown below.**
(4) **Make several letters on your own. Compare often to the sample and strive for consistency.**

Keep your strokes and letters the same size as the examples, and within the guidelines as shown. Ignore the 'boxes' formed by the diagonal lines.

After you've filled an open area, move your tracing paper and do it again. Do each letter 15-18 times before moving on to the next letter. Do this each practice session.

Suggested Hunt Manufacturing Co. pens: Panache™ Broad, Elegant Writer® Broad, or Speedball® C-2 + Bienfang® 100 Tracing Paper

Check 45° pen angle here

H A
2,3,4,5,2,1

B B
2,3,6,6,9,1

C C
7,8

D D
2,3,6,9,1

E E
2,3,9,2,1

Suggested Hunt Manufacturing Co. pens: Panache™ Broad, Elegant Writer® Broad, or Speedball® C-2 + Bienfang® 100 Tracing Paper

Check 45°
pen angle
here

F F

2,3,4,2,1

G G

7,8,2,3,4

H H

2,3,4,5,8,2,1

J J

3,4,1

J J

2,3,4

K K

2,3,4,6,10,1

L L

3,9,8

M M

2,3,4,11,11,5,1

Suggested Hunt Manufacturing Co. pens: Panache™ Broad, Elegant Writer® Broad, or Speedball® C-2 + Bienfang® 100 Tracing Paper

N N N

2,3,4,11,3,8

O O

7,6

P P P

2,3,4,6,4,1

Q Q Q

7,6,10

R R R

2,3,4,6,10,1 **Note that the R has the same strokes as the K. Change Stroke 6 for the R.**

S S

12,8,4

T T T

2,3,9,1

U U U

2,5,5,1

Suggested Hunt Manufacturing Co. pens: Panache™ Broad, Elegant Writer® Broad, or Speedball® C-2 + Bienfang® 100 Tracing Paper

Check 45°
pen angle
here

V V

2,11,6,1

W W W

2,11,11,11,3,8,1

X X X

2,10,4,1,2

Y Y Y

2,5,3,4,1

Z Z

2,3,9,1

CALLIGRAPHY IN
ALL CAPS IS HARD
TO READ.

Calligraphy in all
caps is hard to read.

TIP: NEVER be tempted to do words in all upper case letters. As you see in the example here, words and messages in all capital letters will likely cross your eyes and give you headaches. And think about the poor souls out there who are trying to read what you have to say.

The Ken Brown Calligraphy Handbook • © 1991 Ken Brown Studio

Layout

Regardless of how well you can do calligraphy, if you cannot assemble words, sentences, and paragraphs in an orderly, attractive layout, your knowledge is incomplete. It's sort of the 'boilerplate' part of calligraphy....not the most pleasant part to do.... but vitally important to any worthwhile project.

There are several ways of getting guidelines on your lettering surface. Here's **the best way**:

The KEN BROWN GUIDELiner®

This template grew out of years of experimentation with all kinds of devices and shortcuts to help get my layout ready for lettering. It's the best tool I know of and I use it every day. It's designed to accommodate over 20 different kinds of pens including dip, reservoir, shadow, and markers.

Pre-measured sets of lines are printed along both sides of the template. <u>These line sets are for lower case letters, 5 penwidths high.</u> A chart in the center lists the sets of lines and the pen designations that will fit each line set. Here are instructions for its use:

1. *Determine the pen to be used for lettering.*
2. *Position the GUIDELiner®, <u>with that pen's set of lines</u>, on your layout at the <u>first line of lettering</u>.*
3. *Put soft-lead pencil dots, on your layout, at the point where the printed lines showing letter height, for your particular pen, bleed off the side of the template. (Lines bleed off for line sets A, C, E, H, & J. Put dots on your layout through the <u>slits</u> near line sets B, D, F, G & I.)*
4. *Use a soft-lead pencil and straightedge to draw parallel lines across your layout, using the dots for letter height and space between lines of calligraphy.*
5. *If you need more sets of lines than given on the template, move the GUIDELiner® up or down as necessary to repeat spacing.*

ITEMS NEEDED FOR LAYOUT

1. **The Ken Brown GUIDELiner® template**
2. **Soft-lead pencil (6B recommended)**
3. **T-square or straightedge for drawing lines.**
4. **Soft white rubber eraser (MAGIC RUB by FaberCastell is recommended)**
5. **Draftsman's brush for removal of erasures.**

BEFORE YOU BEGIN......

NEVER use a hard-lead pencil for guidelines. The misconception is that the hard lead won't make such a

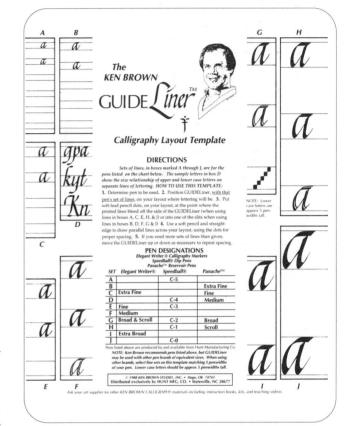

*This 8" x 10" plastic template is the fastest, most efficient way to establish guidelines and spaces for the layout of any lettering job. It's designed to provide properly spaced lines for over 20 different pens. Ask your dealer for **The Ken Brown GUIDELiner® Calligraphy Layout Template** from **HUNT MANUFACTURING CO.** If unavailable locally, order it from **The Ken Brown Studio.***

big ugly mark. That's true. But you'll have to bear down so hard to make the line visible that it will be difficult, if not impossible, to erase it later. You'll make an indentation in the paper that you may not get out.

ALWAYS use a soft-lead pencil. When you're ready to draw the lines, hold the pencil ever-so-lightly at the eraser end and let **only** the weight of the pencil itself ride along your straightedge. If you have a really soft lead, it will make all the line you need and it will erase in a whisper.

ALWAYS test your eraser-ink-paper combination in advance of a job. Get a scrap and see how long it takes to dry. Some papers are coated and the slick finish will take much longer for the ink to be totally absorbed and dried. Some ink may *never* completely be absorbed and there may be a residue left on the surface that will

take hours or even days to dry sufficiently to erase over without smearing your calligraphy.

NEVER use one of those red abrasive erasers! As it erases your guidelines, it'll also visibly scratch, and maybe even remove, portions of your lettering. It'll also scratch your paper surface. Leave the ruby reds to the 4th grader and his Big Chief tablet.

> we the willing, led
> by the unknowing,
> are doing the im-
> possible for the
> ungrateful.
> we have done so
> much for so long
> with so little we are
> now qualified to do
> anything with nothing. ✝

This was inserted here to take up a bit of space, make you smile, and show you a style of calligraphy called Uncial, pronounced "Unk-shull." This style has no upper case and separate lower case. Although some letters have variations, there is basically only one set of characters. Like any other style, Uncial has many different treatments. This is the collection of Uncial letters I like and use most.

Let's pretend.

You've developed your skill to the point people are noticing your work. Someone asks you to do a little project with specific instructions as to size and arrangement of the verse to be calligraphed. You must provide the finished piece exactly as they've requested. Here is the verse:

> *The glow of the morning sunrise,*
> *The fragrance of the dew,*
> *The beauty of a snowfall*
> *Remind me, dear, of you.*

If you've never done any layout, read through this example first, then, with a sheet of paper and a few pens, do the procedure, step-by-step. The first time you <u>must</u> do a layout, you'll be ready.

Here are the specifications and how to use them:

<u>KNOWNS:</u>
1 The final paper size must be 5" x 7".
2 The verse has 4 lines of different lengths.
3 There must be a 1" margin on each side; the longest lettered line must be 5".
3 The verse is to be centered within the <u>vertical</u> space.
4 All lines must have a common left margin.
5 There is no title and no author.

<u>UNKNOWNS</u>
1 The size pen to be used.

THE STEPS

Step 1
Either pre-cut your paper or illustration board to 5" x 7" or use a larger piece with a 5" x 7" border drawn. In this example, the piece was cut to final size. Tape the paper down to your drawing board or work area. Draw a light, dashed horizontal and vertical line through the center of both dimensions.

C-1 *The glow of the morning*

C-2 *The glow of the morning*

C-3 *The glow of the morning sun*

C-4 *The glow of the morning sunrise,*
The fragrance of the dew,
The beauty of a snowfall,
Remind me, dear, of you.

Step 2

On a separate piece of paper, draw two vertical lines 5" apart. (This is the maximum width of your longest allowable line of calligraphy.) Count the letters and spaces to determine the longest line in the poem.

Select a pen that you think will letter the entire longest line within the 5" allotted space. Draw guidelines for that pen across the 5" space.

Letter the longest line of poetry and see if it will fit within the 5". If too long, the pen is too large. Try a smaller pen. Draw the proper set of guidelines for the smaller pen and letter it again.

Repeat this trial and error method until you select the pen that will letter the entire line in the 5" space. In the example above, the **Speedball® C-4** was the correct size pen to letter the whole line in the 5" space.

NOTE: For the sake of example, this exercise uses 4 different HUNT SPEEDBALL® dip pens ranging from C-1 to C-4. If you use the same pens your results may be slightly different, but the steps toward preparing a layout are the same.

Go through the exercise, using whatever brand and size pens you have, to understand the procedure.

Step 3

Since the poem is to be centered in the vertical (height) of the page, there should be two lines above and two lines below the center line. The trial and error lettering showed that the **SPEEDBALL® C-4** would letter whole line in the 5" space. <u>Use the Ken Brown GUIDELiner® to position the line sets for the selected pen.</u>

Since there must be a 1" margin on each side of the paper, draw a light vertical line 1" in from the left side of the paper. Using the sets of lines established by the GUIDELiner®, draw guidelines for the 4 lines of poetry.

From the example, you already know the longest line is exactly 5" long, so there is no need to draw the 1" line on the right.

Step 4

When the guidelines are drawn, letter the verse with the **SPEEDBALL® C-4** pen. Thoroughly erase your guidelines when you're sure they are completely dry.

That's it for just about any layout. The requirements will be different, but the steps are the same.

Eventually, you'll be able to look at the piece to be lettered, and the sheet it goes on, and select the correct pen the first or second time.

AN ADDED REQUIREMENT

Let's say the customer liked what your did, but decides the poem needs one more line. You're asked to letter it again with all the other requirements remaining the same. Here's the poem again, with the added line:

> *The glow of the morning sunrise,*
> *The fragrance of the dew,*
> *The beauty of a snowfall,*
> *Remind me, dear, of you.*
> *The make me think of you.*

Since the longest line is still the first line, you won't need to change pen sizes. You must still center the poem on the page. With an odd number of lines, you now put the middle line of the poem straddling the center line of the layout.

Here is the poem, meeting all the requirements, with the added line.

This layout will accommodate the 5 line poem. You still have two lines above and two lines below the center line, but, to keep the entire poem centered on the sheet, the middle, or third, line of the poem must now straddle the center line of the layout.

Just to cover another possibility, let's say that your customer decides each line of calligraphy should not have a common, flush left margin, but each should be _centered_ about the vertical centerline of the sheet.

To be certain each line of calligraphy is exactly centered about the vertical center line of the layout, you must letter each line of the verse, on a separate work sheet, and measure it. Wedding invitations are usually formatted this way.

TIP: You'll have better control of your layouts and the drawing of your layouts and guidelines if you have a table with a straight edge to accommodate a small T-square.

Draw guidelines on your layout sheet. The first line you lettered was 5" long. On your layout, measure 2-1/2" on the left of the center line and 2-1/2" on the right. Measure each line of lettering you did on the Worksheet and measure half the length of each line of calligraphy on the right and left of the vertical center line. Put little markings on each line indicating where you should begin and end that particular line of lettering.

Here is the way the new layout should look when each line is centered about the vertical center line.

In each arrangement, when you've finished the lettering, be certain the ink is completely dry before erasing your guidelines.

Up to this point, we've been working to produce **original calligraphy** being paid for by a customer. Guidelines are drawn with a soft-leaded pencil, to be erased later. Calligraphy is done within the specifications as to size and arrangement. No mistakes are allowed since they are virtually impossible to correct and hide, especially when working on paper.

Of course these exercises, in your mind, may be strictly for your own use with no plans to sell anything. Whether or not you ever work for someone else, you still must know and understand how to make a proper layout.

CAMERA-READY CALLIGRAPHY

There's another way.

Again, for the sake of example, let's assume your customer wants this poem reproduced by the local printer. Maybe he wants 100 copies for friends. The customer doesn't want the original, just the copies done in your calligraphy.

You can save lots of time and energy by preparing a **camera-ready artwork.** Here's where you can use that wonderful clay-coated paper I talked about earlier on page 21.

If you know, going in, that a perfect original is not the goal, use a non-repro blue pencil or marker for your guidelines. If you use the slick paper, use the marker.

If you start with a sheet of paper larger than the final size is to be, you can do the calligraphy in the middle of the sheet and not worry about centering the whole piece in a specific size. When you've finished lettering, merely draw the outside *box,* to the dimensions of the final size, around the completed lettering. Then cut it out of the center of the sheet.

You can write instructions to the printer right on the artwork, as long as you do it in non-repro blue. On the next page is a photo of the marked-up artwork with instructions to the printer.

The Ken Brown Calligraphy Handbook • © 1991 Ken Brown Studio

This is how the piece looked after I lettered it on the clay-coated paper, using a non-reproducible blue marker for my guidelines, center lines, and notes.

If you make a mistake in lettering, merely snip out the error with an **X-ACTO**® knife or razor blade. Patch the hole in your layout with a new piece of paper where you've lettered the correction. You can also cover up the error with another piece of paper, then re-letter. Correction fluids, masking tape patched places, and other fix-ups don't show when photographed. The printer uses a special high-contrast film that doesn't *see* anything but your black ink.

When you prepare your work for the printer as a camera-ready art, it may look like something given up by the garbage can. Fortunately, you and the printer are the only ones who have to know.

> The glow of the morning sunrise,
> The fragrance of the dew,
> The beauty of a snowfall,
> Remind me, dear, of you.
> They make me think of you.

This is the same camera-ready calligraphy, as shown above, as the printer's camera sees it. The camera's copy of the work can be printed in any size, in any color, and on any paper you choose. All your errors and corrections will be your secret. And the printer's.

Before you tackle a job you plan to have reproduced, consult with a commercial printer. It can be a large firm or the little print shop around the corner. Let the printer know what you want to do and discuss what you can and cannot do before you bring your work there.

Discuss ink and paper colors. Decide on paper quality and weight. You'll be greatly enlightened and probably save some time before you begin work.

HOW DO I CHARGE THE CUSTOMER?

If all these exercises and examples had been an actual experience you had with a customer, you would have many decisions to make. How do you charge for the initial request? How do you charge when the customer changes his mind mid-stream?

How do you charge for a perfect original as opposed to a camera-ready artwork that takes you far less time? How do you handle the printing charges? Do you offer the customer a *turn-key* job and add profit to the printing charges or do you let the customer pay you, then handle printing details himself?

A SPECIAL BOOK TELLS HOW

If you're interested in pursuing this part of calligraphy, ask your local retailer for **The Ken Brown Calligraphy Resource Guide** from **HUNT MANUFACTURING CO.** This book is packed with ideas for producing, promoting, pricing, and copyrighting your work. It's loaded with photos and ideas to help you in countless ways.

I've included the best of over 25 years of my personal experiences with every conceivable aspect of calligraphy.

If you can't get it where you are, order the book from The Ken Brown Studio.

MORE ABOUT CAMERA-READY CALLIGRAPHY

As I've always said, _never_ do important originals or work to be published with calligraphy markers. But, to prove that it _can_ be done satisfactorily, I did a wedding invitation with Elegant Writers®.

I used the slick, clay-coated paper with blue non-repro guidelines. To keep the strokes as crisp as possible all the way through, I did cheat a bit. I used 4 brand new Broad Elegant Writer® markers. The instant I sensed the pen was losing its sharpness, I started with a new one. For less than five dollars in materials, the master, worth a $100.00 fee, was done.

I used two sheets to do the lettering, without regard to centering or placement. After the lettering was done, I photographed the two sheets and made reduced copies on my darkroom camera. (*This is a tool you don't have; for a few dollars, a commercial printer can reduce your oversized originals for paste-up of the smaller pieces.*)

I then cut and pasted the small photocopies on the vertical centerline, on a sheet of paper. That paste-up was then shot on the camera which 'saw' only the black ink and not the edges of the pasted-up strips.

TOP: The two sheets of lettering for the camera-ready wedding invitation. All calligraphy was done with the Broad, Brown Elegant Writer® Calligraphy Marker. If I made an error, I merely started over. This lettering was done without regard to centering or placement.

ABOVE: This is the photo positive shot of the paste-up of the small, individual pieces. The printer's camera doesn't 'see' the lines around the small paste-up pieces of calligraphy. This, then became the master to be shot into a film negative for offset reproduction by a commercial printing firm.

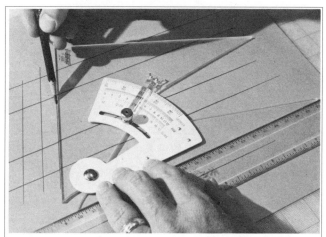

TIP: You can set an adjustable triangle to any desired angle of slant for your letters. As you slide it along a T-square or drafting machine, your setting will allow you to draw guidelines along the side of the triangle.

TIP: Clean up with a big, long-bristle brush. Don't be tempted to pucker up and blow away the little bits of dirty eraser and dust created by the erasing of your guidelines. Without fail, a bit of saliva, or even misty breath, will melt away your precious lettering. Water soluble ink can't take the moisture. If you've gotta pucker, then whistle a happy tune, away from your calligraphy!

The Ken Brown Calligraphy Handbook • © 1991 Ken Brown Studio

Flourishes

Become familiar with ways some letters can be changed dramatically with the swash of the pen, yet remain distinctively recognizable. Often at the end of a line, excessive space will remain. If the line ends with a letter that can be flourished, you'll create balance and visual appeal when you add the appropriate dressing.

In the illustrations below, you'll see how I've flourished some of the letters in my own Chancery Cursive style. I've also included variations to show how some letters can be made in different ways. Study and practice them. You'll surely discover other ways of adding parts, to the same letters, in ways I've never even thought of.

Notice how I've done letters in various ways in the examples throughout the book. Look for letter combinations that lend themselves to interesting combinations.

Trace the characters below to get the rhythm of their formation. Then try them on your own using a wider pen to give you better contrasts in stroke weight than shown in the small samples.

Suggested Hunt Manufacturing Co. pens: Panache™ Extra Fine or Speedball® C-5 + Bienfang® 100 Tracing Paper

A A A B C C D E E F
F G H H H I J I T T T
K K K K L L M M M
N N N O P P P Q Q 2
R R R R S S T U
V W X Y Y Y Z

a b b b c d d e e f f g h h h
h h h i i j j k k k k l l m m
n n o p p p q r r r s s St
t t u v w x y y y z z

1 2 2 3 4 4 5 5 6 7 7 8 9 9 0

& & !? $ ¢ ,, — — † : = () " " ()

Ascenders & Descenders

You can add some inventive designs to your calligraphy when you tie ascenders and descenders together. As you do lines of poetry, paragraphs, or even an address on an envelope, don't complete the descenders...the tails of the g's, f's, p's, j's, etc....as you do a line of lettering. Wait until you get to the next line and see how you can 'blend' them with the ascenders...the tops of b's, d's, l's, etc...of letters in the line below. Always complete the descenders from the line above as you work on the current line.

Notice how I've done them in samples throughout this book. Find combinations that you like and try them on your own. Become aware of your own opportunities when you letter several lines of work that might be given a visual boost by your creative connections.

Be careful not to overdo it. Too many connections and fancy stuff can look contrived and confusing.

REMEMBER: Don't complete the descenders as you letter a line; save them until you work on the next line below.

Life After Forty

signs on how to know you're growing older

Everything hurts and what doesn't hurt doesn't work.

The gleam in your eyes is from the sun hitting your bifocals.

Your children begin to look middle age.

You feel like the 'night before' and you haven't been anywhere.

Your little black book contains only names ending in M.D.

You look forward to a dull evening.

Your knees buckle but your belt won't.

Your favorite part of the newspaper is "25 years ago today."

You sit in a rocking chair and can't get it going.

Dialing long distance wears you out.

Your back goes out more often than you do.

A fortune teller offers to read your face.

You turn off the lights for economic reasons, not romantic ones.

You are startled the first time someone calls you "old-timer."

You burn the midnight oil after 8 p.m.

You sink your teeth into a piece of steak and they stay there.

You have a walk-in medicine chest.

But.....

Enjoy life. Consider the alternative.

©1981 Ken Brown Studio • Hugo, OK 74743

The Ken Brown Calligraphy Handbook • © 1991 Ken Brown Studio

Lettering on Wood

Some of my most creative, promotional, and productive projects have been on wood. Way back in the beginning of my calligraphy experience, I was starved for attention to my new-found skill. When I'd do something on wood, it seemed to draw more attention than anything else.

You can do it too. First, select the piece of wood you want to use. It may be a flat board from the lumber yard or a scrap from under the workbench. The piece should be free of knots or other irregular places on the surface. If you want a special pattern or shape, use a small electric hobby saw to cut it out. When you have the piece sized and shaped, here's what you do:

1 Have a separate piece of wood to TEST. Do all the following steps on the test piece BEFORE you begin on the actual project. If the test works, repeat all steps below on the real thing.
2 Select the best side for your layout. Sand the piece smooth. Be sure the edges are smooth. Brush away all dust.
3 To seal the pores of the wood, use a water-base sealer. My favorite is MOD PODGE. Follow directions on the container; the sealer dries clear. Be sure it's dry before you begin work.
4 Use a soft-lead pencil (6B) to draw guidelines.
5 Use dip pens and permanent ink on wood. With a slightly lighter-than-usual pressure of pen to surface, letter your words on the dried MOD PODGE.
6 When completely dry, use a soft, white eraser to remove the guidelines.
7 Place the piece on newspapers in a well-ventilated area and seal the ink with a clear acrylic spray. I prefer DEFT CLEAR WOOD FINISH. It dries completely clear and locks the ink between it and the MOD PODGE. The finished product will be beautiful and the ink will appear to have been lettered directly on the wood grain.
 Of course, if you want to <u>paint</u> the wood with a color, the MOD PODGE may not be necessary. The paint should take the ink o.k. When the ink is dry, follow the spraying directions to put the clear, protective finish on with DEFT.

1

THE PHOTOS

1 Cutout of my hand. Message on one side and address on the other. Mailed 45, unwrapped, as promotion.
2 Mailed 22 with message on both sides of the slats. Resulted in a $10,000.00 order from one customer.
3 Get-well message to Dad. Each item above mailed unwrapped, FIRST CLASS through U.S........ Postal System.
4 The products for lettering on wood.

2

4 **3**

In CONGRESS, July 4, 1776

The unanimous Declaration of the thirteen united States of America

[The full text of the United States Declaration of Independence, hand-lettered in calligraphy, followed by the signers' names arranged in columns.]

When I was a kid, it fascinated me to watch the Hugo sign-painter, Henry Lyles, Jr., letter large signs. I felt it would be fun to have a big piece of work on display. Since those days of sitting at the foot of Henry's ladder, I've dreamed of painting my own billboard; this is probably as close as I'll ever get.

In March of 1976, a dear friend and classmate, Wyndol Fry, the high school carpentry teacher, found a large sheet of birch plywood. After sanding and preparing the board for lettering, I spent three consecutive all-night sessions on layout and lettering. I used various SPEEDBALL® dip pens for the headlines and two different reservoir pens for the rest.

The framed piece was the focal point of our display in a regional art show held in Dallas, Texas, in April, 1976. Then it went to Philadelphia for display at another art exhibit.

From Philadelphia, it was taken to Washington, D.C. Ceci Wolfe, another close friend and classmate, worked for the Honorable Carl Albert, Speaker of the House of Representatives. Through their help, the piece was put on public display for several months in the Sam Rayburn Office Building in Washington. It was also featured in both my tv series.

I'm standing by my 'billboard' in Mr. Albert's Washington office. It now hangs in my studio office.

4/4/81

2-24-79

Dear Ken & Gail,
Thanks for the new book I think it's great.
As you can see, you will never have to worry about competetion from me.
I appreciate your thoughtfulness. Come see us!
Frank

It's an adventure to open the mail every day and see what people have to say. Often, it's not what they say, but the appearance of the message that makes it special. I appreciate the fact that it probably took an hour or two or three for some of the letters and samples to be calligraphed. It's obvious that others were completed in 3 minutes flat.

I thought you'd enjoy seeing some of the diversity in the letters I get. I'd love to get one from you too!

Dear Mr. Ken Brown,

If you remember I wrote you a letter requesting a Calligraphic information bibliography, which I received. I have taken your advice and have written the firm you suggested. I merely wanted to thank you for your kind attention, and especially for giving me an example of your beautiful penmanship. I have also purchased one of your Calligraphy Kits and I'm very pleased with it.

Thanks again,
Peggy Riley

ken brown
P.O. Box 637
Hugo, Oklahoma

November 1, 1979

Dear Ken Brown,
I'm sorry I haven't written sooner but I've been kind of busy with school. This year I've been doing a lot of Calligraphy and other people are doing it too. The 6th grade is different but I like it. I have a very interesting teacher. I'm having a lot of fun with Calligraphy. Maybe I can make money with Calligraphy someday.

Your Pen Friend,
Michael Maples

P.S. How are you doing?

Ken Brown Studio
Box 637
Hugo, Oklahoma 74743

Dear Ken,
Please send a current issue of you catalog. I'm going to be teaching a workshop in beginning "Calligraphy" and will need to order supplies.
I have not ordered for about two years as I didn't feel qualified to teach until I really did some HEAVY practice myself!
(I hope you still have a copy of my original order to compare with!) Now I can't wait to use up all of this TERRIBLE letterhead and get new printed. Thank you so much -- you've opened a whole new world for me.

Sincerely
Karole

Dear Mr. Brown:
I am 17 years old. I am very happy to have taken Calligraphy in Art Class. Your brochures have helped me a lot this year. I still need lots of work, but I hope some day to be as good as you and your wife. If you have any tips on how to become a good writer or on any brochures I should read, I would really appreciate it if you would let me know.
Good Luck!, and Thank You for your time.

Your Friend,
Miss Sandy Cole

Ken Brown Studio
Box 637 Central at 7th
Hugo, Oklahoma 74743

Dear Mr. Brown,
It would be greatly appreciated if you would send your catalog of prints. I am a beginner as you tell and have a long way to go.
Respectfully,
Norma Ifun

April 6, 1979

Dear Ken
As a beginning calligraphy teacher, I have been impressed with the reception your textbook and artistic samples have won. Many of my students bring your text to class asking me to help them write like you.
Thank you for being great!
Mary Ravensborg

Ken Brown,
Please send your catalog As you can see, I need the practice sheets.
Thank You,
Betty Jo Dillon

The Ken Brown Studio
Post Office Box 637 BK
Hugo, Okla. 74743

Please send me a catalog of your products. I am trying to learn Calligraphy.
Sincerely,
Theodore Moore

Dec. 27, MCMLXXIX.

Mr. Ken Brown,
Studio of Calligraphic Art.

Dear Sir,
In order to get a complete set of The Ken Brown Handbook, Calligraphic lettering pen set, Special Calligraphic Ink and Antique Parchment paper, I am sending you these lines, so you'll be so kind in telling me what's its price and if it is possible to send it here, Mexico City. I saw your announce in a last year magazines, so I am asking you this.
Receive, my best season's greetings. I wait for your reply,
Thanks,
Rogelio Rodriguez

Dear Sirs:
Would you please send me your current catalog.
Thank you,
Ann Egan

Cali, Enero 25 de 1980 2ª Carta

Señor Ken Brown
Estimado Señor: hace aproximadamente 8 meses le envié una carta pidiéndole el concepto de mi caligrafía ya que yo soy el Campeón de Colombia, pero quería saber si ustedes tienen un método superior para acabar de tecnificar mi letra. En la actualidad estoy enseñando 14 tipos de letra y si allá están interesados en mi trabajo les ruego el favor de contestarme pues estoy dispuesto a viajar allá a Estados Unidos, mi dirección es Diagonal 24C #1.25-93 Barrio 20 de Julio Cali, Colombia. Esta es la 2ª carta y estuve esperando su respuesta por 8 meses y no llegó espero que en esta oportunidad me conteste.

Please send me your complete catalogue of calligraphy supplies.

Jas Babcock

To whom it may concern:
Regarding: A catalog of supplies, schools professional techniques, and any other such information on the art of writing. All of this if possible.
I would greatly appreciate your help.
Thank You,
Mrs. Betty Jean Mitchell

Dear Ken,
I've read your books on Calligraphy, and think they are great. Also, I really like your wife's art work.
I am a girl, 17, and have been doing Calligraphy for 3 years now. I am self-taught, and have read your books and other books. Several people have had me do some calligraphic work for them. So far, it's been free, no charge.
I am a little apprehensive about writing to you, but any help in this area would be deeply appreciated.
Sincerely,
Tonya Griffin

May I have a copy of your product catalog.
Thank you.
MARJORIE CANNON

Jan. 21 - 81

Dear Ken Brown, calligrapher,

I am a Senior citizen & started doing this, two years ago & would appreciate suggestions or corrections

Sincerely,
Vi Green

Grant me
Courage and Hope
for every day,
Faith to guide me
along my way. P.S.
Understanding and
Wisdom, too,
And Grace to accept
what life gives me to do.

Ken Brown Studio Vi Green

Ken Brown Studio
Box M637
Hugo, Oklahoma 74743
Dear Mr. or Ms:

I saw your ad in the April 1979 issue of the Smithsonian magazine. Please send me your catalogue of calligraphic tools, materials and supplies, complete with costs and ordering data.

Thank you!
Yours truly,
Howard Wells

Dear Ken,

I am a great admirer of your Calligraphic work. To me you are the world's best Calligraphy artist. Please coment on my work.
Sincerely,
Jamie Westbrook

Mr. Ken Brown
P.O. Box 637 TC
Hugo, Ok. 74743

Dear Mr. Brown -

I would like to know if I may buy Calligraphic supplies, by mail, from you. If so, do you have a price list that you can send me?

I learned of your studio from a friend, who showed me an example of your Calligraphy. I sincerely admired your work.

Any help you can give me will be greatly appreciated.

Respectfully,

George H. Bergevin

Dear Sir:

I purchased your calligraphy book, "The Ken Brown Handbook" and it proves to be a very useful guide. I do like calligraphy very much and I am using this book dilingently every day.

Your book mentions 'dividers' for letter spacing. I do not understand how this is done. Can you clarify this? Do you have any other calligraphy books available, and my last question, what is the best type of paper that can be purchased?

Your reply is gratefully appreciated.

Very truly yours,
Gilbert Aloysius

P.S. Your criticism to this calligraphy letter is most appreciated.

Dear Ken, Gail (or whoever opens the mail),

I'm trying to teach myself how to write pretty. I have your handbook, your "Deluxe Ken Brown Calligraphy Kit", and a lot of determination.

Thanks for this beautiful hobby

Wesley M. Shaw
NOVICE SCRIBE.

Dear Mr. Brown,

Last month I became a student of calligraphy and I love it! I write on anything that doesn't run when I grab my ink bottle! It's nice to see a book out by a fellow Okie. I'm from Alva, which is over by Enid and Cherokee.

Happy lettering!
Mrs. Janice Medley

P.S. Perhaps you could send me a price list of the products available from your studio.

Dear Ken -

Please send me your product catalog and any information about your new book - Volume 2

Thanks - Jack O'Connor

Dear Sir;

Please send the product catalog showing all calligraphic items produced by Ken Brown to;

Marilyn Mendeloff
832 Cherry Hill

Mr. Keen Brown
Studio of Calligraphic Art

Sir:

I should know the actual price of "The ken brown handbook," Calligraphic Lettering Pen Set, that I saw in a National Geographic magazine from 1978; as so, I imagine the price are not the same.

With your answer I shall send you the check, including the price of the sending with my very thanks. I wait for you letter.

Mr. Mario Román
La Concepción 311
Santiago ~ Chile. ~ .

Dear Ken & Co:

I have your Calligraphy Book Vol-I.
It's great!

I would appreciate your "complete Catalog" of your products.

Thank You

Dear Sir:
I am interested in obtaining a copy of your catalogue. Kindly forward it to me at the above address. Thank you.

Sincerely,
Sister Barbara Tracey

Dear Ken and Gail,
I bought your book from the Dick Blick Co — it's the best one I have ever seen! Do you have any others? I've started to Practice on the styles in your book — have a long way to go yet tho'. I would like to have one of your product catalogs. I've been lettering for about 10 yrs — just for the heck of getting things going — and went to work full time about 6 yrs. ago — so it kind of cuts into my lettering time — however people do keep me busy! I've thought about starting a business such as yours — we do not have one in Decatur. Your book — and reading about how you and Gail have done has given me more incentive! Thanks! I will send you a copy of some of my styles —

Thanks again for a great book Will be looking forward to receiving your catalog

Sincerely
Myrna Quinlan

Calligraphy and illustrations are photographically reduced on this and all other sample artworks throughout this book.

The Ken Brown Calligraphy Handbook • © 1991 Ken Brown Studio

Uses For Calligraphy

Stretch your imagination a bit and don't limit your calligraphic endeavors to letters and envelopes. Here's a two-page spread showing just a few ways we've put calligraphy to work beyond the usual fancy envelope or party invitation.

Some of these photos, and many more, with explanations, are found in **The Ken Brown Calligraphy Resource Guide.** This book covers the first 25 years of my experiences in calligraphy. It's not an instruction book, but a wealth of ideas on creating, producing, promoting, pricing, and selling your own calligraphy. It's packed with interesting ideas and ways to help **you** profit from **your** skills.

It will be an invaluable book, wotrh many times its cost, that should be in your reference library. Ask your local art dealer for the book, available from **Hunt Manufacturing Co.**

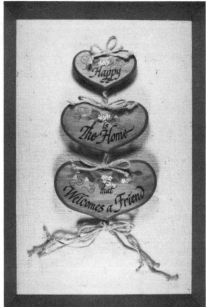

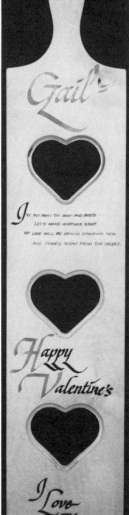

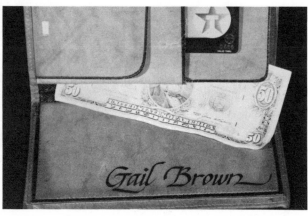

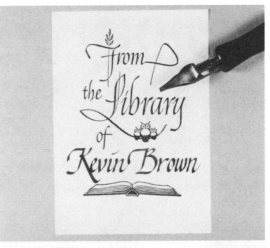

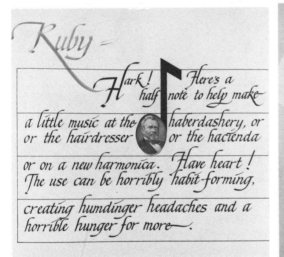

The Ken Brown Calligraphy Handbook • © 1991 Ken Brown Studio

BrownLines™

A NEWSLETTER FOR CALLIGRAPHERS FROM KEN BROWN.

ISSUE NUMBER FIVE AUGUST 1987

KEN BROWN STUDIO OF CALLIGRAPHIC ART, INC. • 702 EAST CENTRAL • BOX 637BL • HUGO, OK 74743 • 405/326-7544

THIS ISSUE BELONGS TO

To give you the flavor of our newsletter, and show you how it shares, entertains, and instructs, here are two pages from past issues. See subscription information attached or order your subscription by calling our toll free number 1-800-654-6100.

TOP DRAWER

— Ken Brown

The writing of this column in the previous issue took place during the spring carp spawn in Hugo, Oklahoma. This time it's being written while the rainbow trout are jumping out of the stream, 20 feet from our back door in Red River, New Mexico. At this moment, it's 9:40 p.m and Gail is standing, dressed to the hilt in waders, in the middle of the stream fishing for my supper. She's put in about 12 hours of fishing today. I literally keep the frying pan hot and she keeps it full of fish. She won't eat the trout but she has an incurable fever to catch them.

Each year we spend two weeks of July in the mountains of northeastern New Mexico. Gail brings her trout gear and I bring my word processor. Yeah, I know it sounds preposterous but it's the most productive two weeks all year for both of us. I always plan a project to work on while the cool mountain breezes blow through our rented condo. My mental gears shift into their most creative mode in this lazy little mountain village where it rains almost every afternoon. There are no phones to answer and no unannounced visitors to distract my concentration. Gail fishes. I write. It's wonderful.

Last year's project was the creation of **BrownLines**. Yesterday, I completed the first draft of a new book. The idea for this book has rattled around in my head for years; now it's on paper. **THE KEN BROWN CALLIGRAPHY RESOURCE GUIDE** covers numerous aspects of calligraphy in great detail. It's not an instruction book. It's filled with information about advancing and profitably utilizing your skills. It provides answers to the countless questions I get weekly from students and customers. More about the book on page 7.

WORKSHOPS & DEMOS

In late June, Gail and I conducted two workshops for a great bunch of folks in Fort Worth, Texas. A total of 40 individuals enrolled for the two classes. We had the pleasure of meeting several of our subscribers for the first time. Young Tom Gray, featured on page 5 of

(cont. on page 8)

San Francisco's ALAN BLACKMAN is a perfectionist. His calligraphic design is exquisite in every detail and is his sole source of income. His passion is FIRST DAY OF ISSUE stamps; he'll sometimes spend a week designing the lettering for one.

THE ROUGH DRAFT

A rough draft is merely an informal, loosely sketched 'map' of how your finished project is to look. The investment of a few minutes in making the draft can save lots of time in actual production of the original.

First, decide on the overall dimensions of the sheet or illustration board you'll do your work on. Then determine the margins, or white space, around the lettering. Draw those margins with a *soft* lead pencil. Within those boundaries you must put your calligraphy and illustrations, if any.

The most effective way for me is to tape down a sheet of tracing paper *over* the surface I'll do the original on. If the piece is a poem, I find the poem's longest line and, through trial and error, select the appropriate pen size to letter that line within the margins, on the tracing paper. Guidelines must be drawn, properly spaced, for each pen tested until the one is found that will letter the longest line to fit. The fastest, most efficient tool for this is *THE KEN BROWN GUIDELiner.*

If the piece is a paragraph of text that can flow as necessary, I letter a couple of lines with a pen size I think will work. After doing two or three lines, I can count words and lines remaining and know if that pen will make it all fit.

Usually, when I've found the right pen, I'll quickly letter the entire piece on the tracing paper with an *Elegant Writer* calligraphy marker. I select the marker that is closest in penwidth to the *Speedball* dip-pen or reservoir nib I'll use on the original. When the rough draft on the tracing sheet is complete, then I peel it away and use it as a guide when lettering the real thing. The draft shows areas where I should either tighten or space out my work in certain areas.

As you become more proficient, you'll find that many of your tasks can be done without the draft. It's still a good warm-up exercise that can be quite revealing if you take the time before you race headlong into the project.

—KB

MONOGRAMS

Here are a few examples of monograms done with various calligraphy pens. Let these stimulate your imagination to create some of your own. Share them with *BrownLines.*

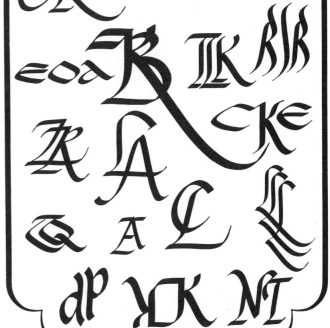

ABECEDARIAN SENTENCES

Vellum, parchment, reed and quill along with ink featly juxtaposed is zilch without the scribe.

If you haven't tried to create one of these, you're missing some fun. This is my second shortest so far, with 39 letters, including all 26 in the alphabet.

—KB

Zany lake frogs act queer jumping bad wax hives.

Richard Anderson finds himself winner in two categories in this issue. in addition to submitting the best limerick, his special sentence was also chosen. Congratulations Richard.

At right is work sent in by Beth Johnson of Auburn Hills, Michigan. She used a Brause #11/2 dip pen and took 10 hours to complete the job. She's been lettering for 6 years and spends 10-12 hours per week dqing calligraphy. Beth mentioned that the sketch of the cat was her **first** attempt at drawing.

Calligraphy and poem by Beth Johnson

*You're as silly as can be
as you run around chasing me
Sometimes you're so quiet
I don't even know you're here
Other times you cuddle
just to be near
You love to wake me up
in the middle of the night
Just to make sure everything's all right
You bang on cupboards
and scratch the closet door
And when that's not enough
you try some more
You can be cute, you can be cool
as you try to break every rule
But when you're playful and loving
there's nothing better than that
And it reminds me once again
you're my very favorite cat.*

A **BrownLines** subscription is a series of six issues. The newsletter is published approximately, though not absolutely, every 90 days, by THE KEN BROWN STUDIO OF CALLIGRAPHIC ART, 702 E. Central, P.O. Box 637 Hugo, OK 74743. All material in this publication is copyrighted and may not be reproduced in any way without written permission from The Ken Brown Studio. *FIRST SERIES* Charter Subscription rate is **$23.00.** Renewals for a series of 6 issues is **$18.00.** Foreign costs are **15% more,** payable in U.S. funds. Subscription may be mailed to the above address or phoned in and charged to VISA or MC. Call **TOLL FREE, 1-800-654-6100** 9:00 a.m. to 4:00 p.m. Mon-Fri, Central time.

The Ken Brown Calligraphy Handbook • © 1991 Ken Brown Studio

Questions Often Asked

Here are some of the most frequently asked questions I get through the mail and over the phone. Some of theses same questions may have arisen in your mind already. If you have questions not covered here, please write or call; I'll make every effort to respond with an answer.

HOW LONG WILL IT TAKE ME TO LEARN?

It's strictly an individual matter. If you follow the exercises in the *Worksheets* in this book, you'll be forming complete characters almost immediately. Like learning anything else, there's no universal timetable for levels of development. Go at your own comfortable speed, spending as much time as necessary on your problem areas.

WHAT IF I MAKE A MISTAKE ON AN ORIGINAL?

Keep a crying towel handy. Even though some inks are non-permanent or non-waterproof, generally, you cannot erase or correct the error satisfactorily. Unless you're working on a thick, high-quality illustration board you'll probably wear through the paper before the ink comes off. If you are lettering on something heavier than paper, you have a better chance for correction. With an abrasive eraser or razor blade, you may be able to remove small mistakes that won't be noticed later. The key here is ultimate concentration. Just don't err!

HOW DO I PROTECT MY PRIZED ORIGINAL IF I'VE USED NON-PERMANENT INK?

First, use great caution while you're working on it. A v o i d any moisture on the working surface. Sweaty hands, coffee, and all other liquids should be nowhere near your lettering.

Regardless of the ink used...permanent or not...you should seal the work with a clear acrylic spray. When the ink is dry, the guidelines are erased, and you've brushed away all the dust, put the piece on newspapers in the garage or some other well-ventilated area. Follow the directions on the can and spray with DEFT, FIXATIVE, KRYLON, or some other aerosol designed for this purpose.

For heaven's sake, if you feel a sneeze coming on before you've sealed your work, turn and run the other direction.

WHAT KIND OF PAPER SHOULD I USE?

That depends upon your intended use. For strictly practice, a lined legal pad is o.k. if you aren't too concerned with exact letter height and line spacing. *The Ken Brown Calligraphy Practice Pad* is better for practice. For originals, use the best quality stock you can find and afford. If you're doing a certificate or award, ask a local printer for some blank stock certificates.

Paper with a high rag content is usually best. When searching for paper, take your pen with you. Ask the merchant for swatches of the paper for you to try before you buy. Commercial paper wholesalers usually have promotional packets they'll gladly give you at no charge.

Many calligraphers insist on using parchment paper for everything. Test it before you load up on paper that might work better in the dispenser on the wall of the necessary room.

WHEN DO I USE THE CHISEL-POINT FELT TIP PENS FOR DOING CALLIGRAPHY?

As with paper, a wide range of quality may be found in this type marker. The Speedball® *Elegant Writer*® is the best available. Where some pens use a soft, felt tip, the *Elegant Writer*® has a durable plastic point for producing sharp, crisp strokes.

There are two distinct advantages in using these pens. They can be used to *write* in longhand....something you should **never** do with any other calligraphy pen. Your normal handwriting takes on a more formal, artistic look when you hold the pen at a 45° angle and then use it like a ballpoint. I've signed my name at the end of this page with an *Elegant Writer*®.

The other advantage is how well they produce calligraphy, when you observe the 5 rules, without the need to fill, refill, and worry about an even ink flow. They're great for kids. They're wonderful for quick, informal notes, invitations, etc. when you want a fancy appearance to your message.

The disadvantage with these and all markers is their relatively short life. They begin to lose their edge and ability to produce contrasting thicks and thins. Since the markers are inexpensive

and disposable, purchase several *Elegant Writer*® to always have fresh ones for your work. They come in several colors and five point sizes, including a *notched* scroll point for producing a double line.

HOW DO I PROMOTE MY CALLIGRAPHY FOR SALE?

It means lots of personal flag-waving. First, be sure you're ready. If people are noticing your work and beginning to ask about your prices and services, you're ready. Decide what kind of jobs you want to do. Special awards, filling in pre-printed certificates, wedding announcements, signs for retail stores, headlines for newspaper advertisers, magazine ads, and dozens of other possibilities exist.

When you're confident you can provide several styles and sizes of calligraphy, contact a small print shop and discuss a promotional flier or mailer. Design an attractive piece showing samples of your calligraphy. List your phone number and address. Distribute them to every business, civic club, and fraternal organization in your area. Take them to funeral homes and chambers of commerce. Let the local banker see your work. Have the local newspaper do a feature story on your skills and have reprints to distribute with your mailing piece. Put a personal note...in calligraphy...to each manager or figurehead where you mail the material.

HOW MUCH DO I CHARGE FOR MY CALLIGRAPHY?

You must decide what your own time is worth to you. If you're doing this strictly for a little extra spending money, and you're willing to work for what you could make waiting tables or pumping gas, then charge that amount. For a *realistic* idea of what your work is worth, talk to a professional artist. Most of them regard hand-lettering with great contempt since most of them can't do it. Ask what their hourly rate is for illustrations and ask what they, or an agency, would pay for professional calligraphy when needed. Try to establish a comparable hourly rate....if your work is indeed at a professional level. You'll probably be able to charge 5 or 6 times the rate you'd get serving meals or servicing gas tanks.

However, **don't** quote an hourly rate for your work; estimate the time it'll take you, multiply the hours by the rate you decide you're worth, and quote a flat fee for the job. If you finish faster, that's great. If it takes you three times as long as you thought, you're still better off than the salaried minimum wage earner. And you can work at home, where you want, when you want, wearing what you want!

WHAT IF SOMEONE WANTS ME TO DO 150 INVITATIONS?

Celebrate! That's a terrific compliment to your abilities. Learn about *camera-ready* calligraphy and talk to a commercial printer about details in reproducing your original.

WHAT IS THE LITTLE FLOWER-LIKE SYMBOL AT THE END OF EACH KEN BROWN PIECE?

That's my own little *finish mark*. Often, my logo and credit line are removed from reproductions. That copyrighted symbol says to all who know my work, "*This calligraphy was done by Ken Brown.*"

If you want to be identified with your own work, where your name might not otherwise appear, create a mark...perhaps a stylized monogram...that you can add to your work. *Please*, for both of us, leave mine alone. It belongs to Ken Brown.

And now I'm finished.

The Ken Brown Calligraphy Handbook • © 1991 Ken Brown Studio

For more detailed information on all these subjects and much more, get **THE KEN BROWN CALLIGRAPHY RESOURCE GUIDE** *, available at your local art store from* HUNT MANUFACTURING CO. *This book is devoted to the production, pricing, promotion, and copyrighting of your calligraphy. If not available locally, order it from The Ken Brown Studio.*

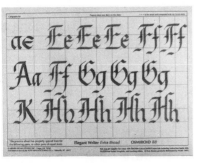

A KEN BROWN VIDEO IS THE NEXT BEST THING TO A PRIVATE LESSON WITH KEN BROWN!

BrownLines™ is a newsletter. It will keep you in touch with other calligraphers and you'll learn what makes Ken Brown tick.

Want to learn faster than you ever imagined? Want to build confidence and a sense of accomplishment right away?

These tapes are packed with easy-to-watch and easy-to-understand instructions. You'll see up-close and personal how the hand position and pen are inter-related and you'll see each stroke of each letter precisely formed. Dozens of samples and ideas fill these videos with information you'll want to see time and time again.

Want to peep over the shoulders of other calligraphers? Want to learn how Ken Brown started and became successful?

Here's a one-of-a-kind newsletter. You'll become encouraged and stimulated to try the ideas shared by other subscribers. You'll learn the ins and outs of how to make several letters in each issue. You'll enjoy the photos and descriptions of this fascinating world of calligraphy that can provide so much pleasure and extra income.

CHANCERY CURSIVE teaches the graceful, flowing script Ken made so popular and easy to do. You'll see every stroke of every letter formed as Ken clearly explains the steps.
OLD ENGLISH breaks down the 'black letter' alphabet and teaches this formal style of lettering used on certificates, awards, diplomas, and other important documents.

UNCIAL is a unique set of upper and lower case characters that make up this alternative set of letterforms. Includes numbers.
TIPS & PROFITS shows shortcuts and suggestions for making calligraphy easier and more fun. Great ideas for earning money with your work. Over 25 years of Ken's experiences to help you benefit most.

BrownLines will plug you into other calligraphers; some may have less experience and expertise than you, but they're all having a great time with calligraphy.
BrownLines is an 8-page, bi-monthly newsletter filled with instructions and tips, along with a continuing Ken Brown column tracing his development in calligra-

phy over a 25 year period. You'll get advance information and discounts on new products. Letters from readers, contests, and photographs make **BrownLines** a valuable tool and indispensable addition to your reference library. You're invited to submit **your** work for possible publication and payment. Come join us. You'll love it!

FOLD

FOLD

FROM:

WORK AT HOME.
EARN THOU$ANDS.

CALLIGRAPHY and *ULTRA-HIGH-SPEED ENGRAVING*
provide a powerful opportunity for YOU to earn
several thousand dollars extra income each year....at home.
NO ARTISTIC TALENT OR EXPERIENCE REQUIRED.

KEN BROWN'S VIDEO SHOWS YOU HOW.

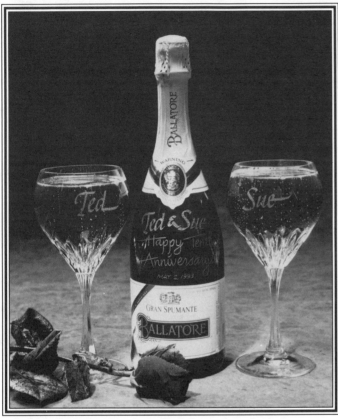

*Personalizing champagne bottles and wine glasses has become
Ken's most productive engraving idea. Realtors, caterers, wedding
planners, and hotels pay handsomely for these prized mementos.
You'll see the step-by-step engraving of this bottle on Ken's video.*
His average profit per 3-piece set is $75.00 per hour.

"**W**ith the two ounce, air-driven, ultra-high-speed Paragrave® drill you see above, _you_ can engrave calligraphy, artwork, logos, or any other design into almost any surface.

I engraved all these items with this easy-to-use drill. Tiny diamond and carbide points, spinning at 400,000 revolutions per minute, make engraving _so easy_. There is no vibration, no heat, and no twist while you use the drill.

It takes no artistic talent or engraving experience to use this marvelous tool. Everything you engrave is traced, using thin mylar stencil sheets.

The _image_ to be engraved, such as line art, logos, and calligraphy can be drawn directly onto the mylar, or copied onto the mylar sheets with an office copier. The self-adhesive sheet is then put on the _item_ to be engraved. You merely trace the image on the mylar. The engraving is being done as you trace.

I'm earning $75.00 per hour engraving champagne bottles and glasses. It's fast and easy and YOU CAN DO IT on your kitchen table.

Take a FREE LOOK AT MY VIDEO and discover how easily you could be earning thousands extra!"

Ken Brown

This expensive crystal vase became more valuable when hand-engraved. Fine gift shops and department stores love to offer unique items that you'll be able to create.

Guns and knives are excellent items to personalize with names and monograms. Sporting goods stores, hunting clubs, and gun shows are excellent places to display and sell your engraving.

This engraving was done on a piece of maple, an extremely hard wood. The hardness allows incredible control and sharp edges for the letterforms. Actual size of the word Calligraphy is about 7."

Extreme detail can be achieved, engraving in metal. The top plate is mild, soft steel; the bottom one is hard stainless. Notice the tiny veins in the eagle feathers. The knives are both stainless and give sharp definition to the engraving. You'll enjoy engraving in metal.

What others are saying about **Paragrave®**

Engrave names on glass and ceramic picture frames for gift shops, department stores, photographers, frame shops, and wedding planners.

Create one-of-a-kind wooden desk plaques. Ask upscale gift shops and stationery stores to display your work for special orders. Your personalized items will command high prices because of the hand-engraved names.

TAKE A FREE LOOK AT KEN'S VIDEO

See how easy calligraphy can be....even if your handwriting is poor and you have no artistic talent. You learn quickly with the Ken Brown method, as millions have with **Ken Brown's Calligraphy for Everyone** on Public Television in the U.S., Canada, and Puerto Rico.

Ken shows you step-by-step how to engrave calligraphy on a desk plaque, a knife, and a champagne bottle using the **Paragrave®** ultra-high-speed engraving system. You'll be amazed at the simplicity.

HOW TO ORDER THE VIDEO

There is a $12.50 returnable deposit.
Call TOLL FREE 1-800-654-6100 and give us your VISA or M'Card number. Or, send your check, or card number, to the Ken Brown Studio. We will not deposit your check or run your charge until 30 days have passed. *You may keep the tape*, but if you should decide to return it within that period, we return your actual deposit check or destroy your unprocessed charge ticket. *Please don't include your deposit payment for this video with your payment for other supplies.*

KEN BROWN WALL CHARTS

Ken Brown's
Chancery Cursive

AAABCCDEEFFGH
HHJJJJJKKKKLL
MMMNNNOPPPQQ2
RRRRSSTUVWXYYY
Z

abbbcdd ee ff ghhk hh hii

j jk

......

Old English

ABCDEF
GHIJKL
MNOPQR
STUVW
XYZ 1234567890

aaaa bbbb ccccdd
ddeeee ffff gggg
hhhh iiiiiiii jjjjkk

Bless This House
Oh Lord we pray;
Make it safe
By night and day.
✝

Creative
Clutter

...etter than
...y idleness.

...hurrier I go the
...ehinder I get. ✝

These handy reference charts are to tape, pin, glue, or stick with your favorite abc gum to the wall behind or to the side of your drawing table, or wherever you do your masterful lettering. They'll save you lots of time flipping pages back in forth in the books looking to see just how a letter looks. You'll find yourself referring to them often as they show variations of letters and numbers. You'll refer to the photos showing hand and pen positions. They also make excellent birdcage liners and, with proper folding, they will soar like a bird. If you're into origami you can fold them into something that looks like that big bird on the kid's show. Oh yes, the actual charts will differ slightly from the depictions hatched up here just before press time. They'll have much more information than you see here. I promise you'll like the real thing or you'll get your money back by special carrier goose who roosts on a set nightly. They're available only in the set of 4 charts. Each chart is packed with helpful, quick references and each is 12" x 18". And the four will roost a gaggle.

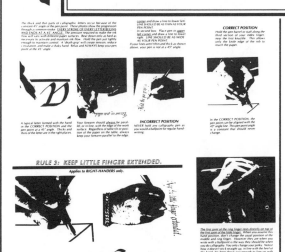

The Rules

fg
no

pqrstuv
wxyz

hard work is the yeast
that raises the dough ✝

uncial

Thank

you for your interest in calligraphy and this book. When you've learned the letters, don't be timid. Share your calligraphy by sending a special hand-scripted greeting to a friend or family member. Brighten someone's day who may be sick at home or in the hospital.

Don't wait until your work becomes perfect; it never will. I'm not ever totally happy with my work but, from the very beginning 30 years ago, it has been a source of great pleasure for me and those getting my little bits and pieces of calligraphy. When I now look at the work I did, with even 3 or 4 years experience, it's obvious it was not very good calligraphy. But, you know, I never once had a complaint or negative comment. Everything I shared was appreciated. Yours will be too.

And while I'm saying Thank You.....

There are several people who keep my wheels turning. This is not a one-man show, but a great team effort.

Thanks to *Gail*.

A man couldn't have a more devoted and loving wife and partner. I'm so fortunate that she shares her wonderful artistic talents, her insights, and her endless patience with me every day.

Thanks to *Kevin*.

Our son has been shooting pictures for 20 years, since the age of 6. When he was 11, he was handling my darkroom chores. His help with the photography in this book was invaluable.

Thanks to *Erin*.

Our daughter cheerfully models for photos, files, copies, sorts, and cleans the debris in the wake of my feverish activities in the darkroom and around my light table during paste-up.

Thanks to *Imogene*.

Our loyal secretary who, for over 15 years, has done everything from open the mail to order materials, to stock, pull, wrap, and ship our books and other products. She is a jewel.

Thanks to *Hunt Manufacturing Co.*

They showed an interest in my work in 1976 and since that time they've continued to promote my name and related products. They distribute my teaching materials in several countries.

Thanks to *Allcraft Printing.*

For over twenty years they've been ferreting out my ideas among mountains of artwork and instructions to produce these books. They've met impossible deadlines and have always been true professionals.

Thanks to *Express Typesetting Co.*

For almost twenty years they've met unattainable deadlines while producing our typography and tolerating my changes of mind and type sizes.

And...

probably most important of all, Thanks to the literally hundreds of thousands of people all over the world who buy my books, learn my method, and enjoy calligraphy in countless ways. They are the ones who really keep things in motion....and that includes a very special note of appreciation to

You.

Ken Brown

The Ken Brown Calligraphy Handbook • © 1991 Ken Brown Studio